Painting
ACRYLIC
LANDSCAPES
the Easy Way

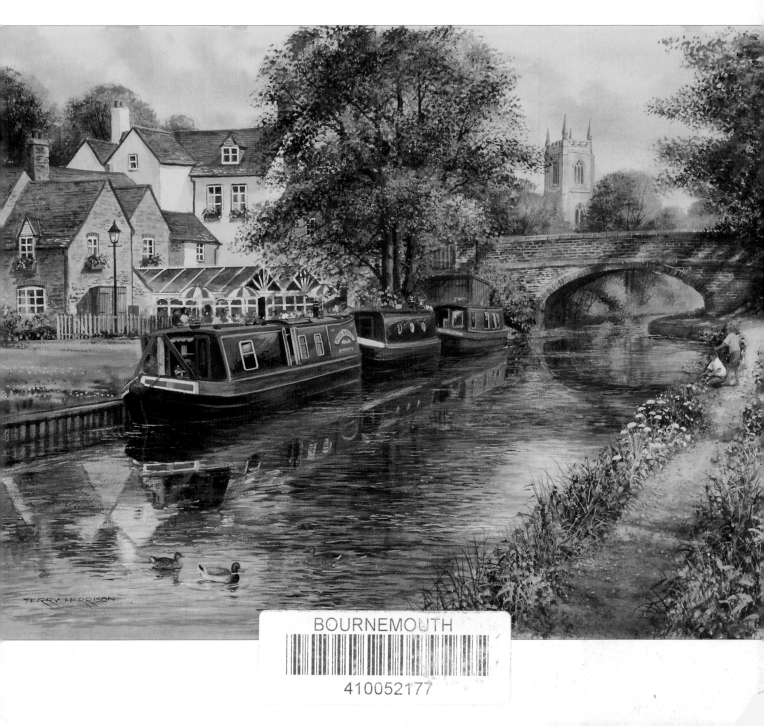

*This book is dedicated to
my wife, Fiona Peart*

Painting
ACRYLIC
LANDSCAPES
the Easy Way
Brush With Acrylics 2

TERRY HARRISON

SEARCH PRESS

First published in Great Britain 2011

Search Press Limited
Wellwood, North Farm Road,
Tunbridge Wells, Kent TN2 3DR

Text copyright © Terry Harrison 2011

Photographs by Roddy Paine Photographic Studios
Photographs and design copyright © Search Press Ltd, 2011

ISBN: 978-1-84448-466-9

The Publishers and author can accept no responsibility for any consequences arising from the information, advice or instructions given in this publication.

Suppliers
If you have any difficulty obtaining any of the materials and equipment mentioned in this book, please contact Terry Harrison at:

Telephone: +44 (0) 1451 820014

Website: **www.terryharrison.com**

Publishers' note
All the step-by-step photographs in this book feature the author, Terry Harrison, demonstrating how to paint landscapes in acrylics. No models have been used.

Page 1: Lunchtime Stopover
One of the many joys of a canal holiday is mooring up at a canal-side pub for lunch, and this also makes a great subject for a painting. The detail in this painting was achieved using brushes with a fine point such as the half-rigger and the round detail brushes. The tree in the centre was painted by stippling with the golden leaf brush and the reflections and ripples were painted using short horizontal brush strokes using the detail brushes as well as the flat brushes.

Printed in Malaysia

Writing a book is not just about painting a few pictures then telling everyone how wonderful and easy it all is – it takes a lot of effort from a lot of people to produce a book for you to enjoy. I would like to thank everyone at Search Press for making this happen, starting with Roz Dace for commissioning me to write this book and Martin de la Bédoyère for agreeing to publish yet another book of mine. Thanks to the team in the office, especially Juan for his creative skills in making this book look good and also Bernie and the boys in the warehouse. (This is beginning to sound like an Oscar speech!) Also thanks to Gavin Sawyer for his stunning photography and once again I have the pleasure of giving my special thanks to Sophie Kersey, my patient and talented editor. Finally thanks to my typing angel, Fiona Peart.

Pages 2/3: Sunset Quay
Painting trees can be daunting, but it helps to keep it simple. The shape of the trees was stippled first using a mid-tone brown and the golden leaf brush. Once dry, the branches and tree trunks were painted over and into the tree shapes using the half-rigger. The clutter of the boats on the quay looks detailed but they are just a jumble of brush strokes with splashes of colour, and a few masts.

Opposite: In the Cool of the Shade
The overhanging trees and shadows create a tunnel effect, pulling the viewer into the painting; the sunlight in the lane is heightened by the use of darks in the trees and the dark dappled shadows across the lane. The reflections in the ford are simply the same colours as the background, repeated in the water using downward brush strokes. The main brush used in this painting was the golden leaf, which was used to create the foliage texture in the trees and the grass verges. The darks of the shadows were painted first using the large detail brush and the dappled light was then added on top.

Pages 8/9: Packhorse Bridge
Most of the brushes and techniques shown in this book were used in this painting: the paper mask was used for the distant fields; the trees and the texture of the stonework were painted using the foliage brush, the detail was emphasised using the half-rigger and the wizard was used for the thatched roof. I have added life to the painting by including the boys paddling in the water and the two 'old boys' having a chat in the lane.

Contents

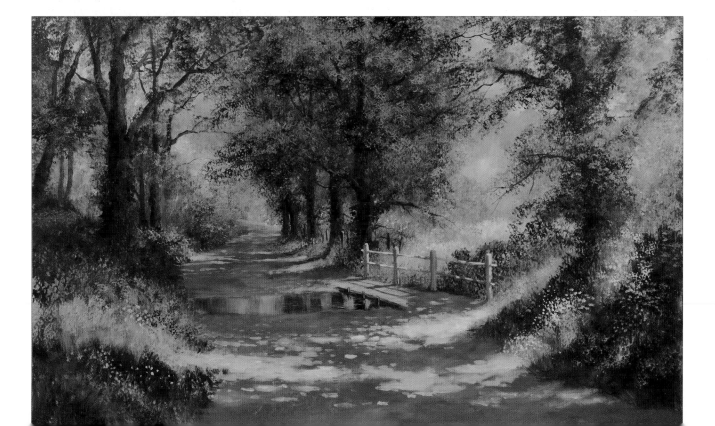

INTRODUCTION

Over the years I have produced many paintings, many of them painted in acrylics. I was introduced to acrylics at art school and at the same time my local art shop began selling these 'new wonder paints'. At first, they attracted their fair share of criticism, mostly from old-school oil painters, or artists who hadn't actually tried them. Acrylics were thought of as 'the poor man's oils', which seemed unfair, as they were then expensive! Other criticisms were that the colours were too bright and garish and that they dried too quickly.

So what a surprise and joy it was to me when I first tried acrylics, and found that this was a truly wonderful medium: so versatile, giving you plenty of choices and means to develop your painting skills. After painting in oils for many years, acrylics seemed so liberating and forgiving. You can use them in an oil painting style or like watercolours, or you can do your own thing and combine the two styles. They have also developed a lot since those early days.

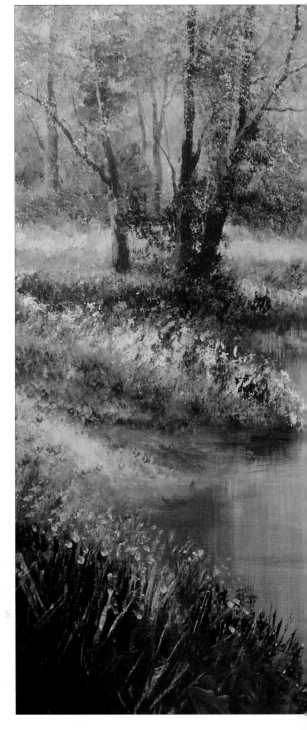

When I began painting, I used traditional brushes, but over the years I have developed my own range of brushes, designed to make painting easier and create certain effects such as textures and simulate foliage and trees. This book shows you different techniques to help you get the most from your brushes and acrylic paint. With many years of experience and success with acrylics, I would like to share with you some of this knowledge, but not in a technical or long-winded, arty way. I have a very simple approach to painting which is illustrated by straightforward and uncomplicated step-by-step demonstrations, with easy to follow instructions. I wish I had had this book when I started out painting all those years ago.

Bluebell Glade

Stippling with the golden leaf brush created the texture of the foliage and foreground in this painting, then, using the same brush and the same colours, the water and reflections were painted using downward brush strokes to mirror the colours of the trees. The reflections were painted vertically, but the ripples on the surface of the water were painted horizontally using the 13mm (¹/₂in) flat brush. The bluebells, which add a contrast in colour, were stippled over a dry background using a mix of cobalt blue, permanent rose and white, using the foliage brush.

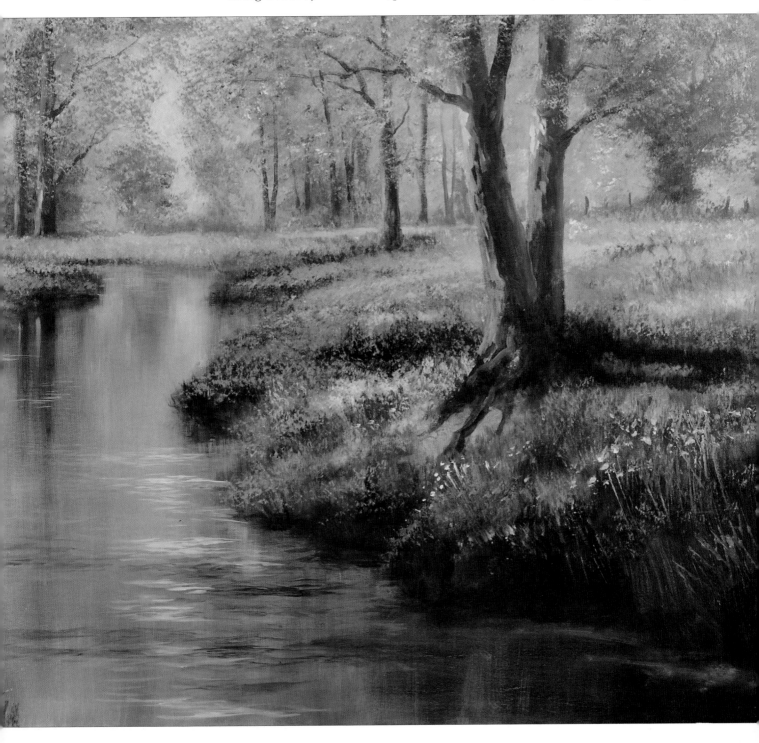

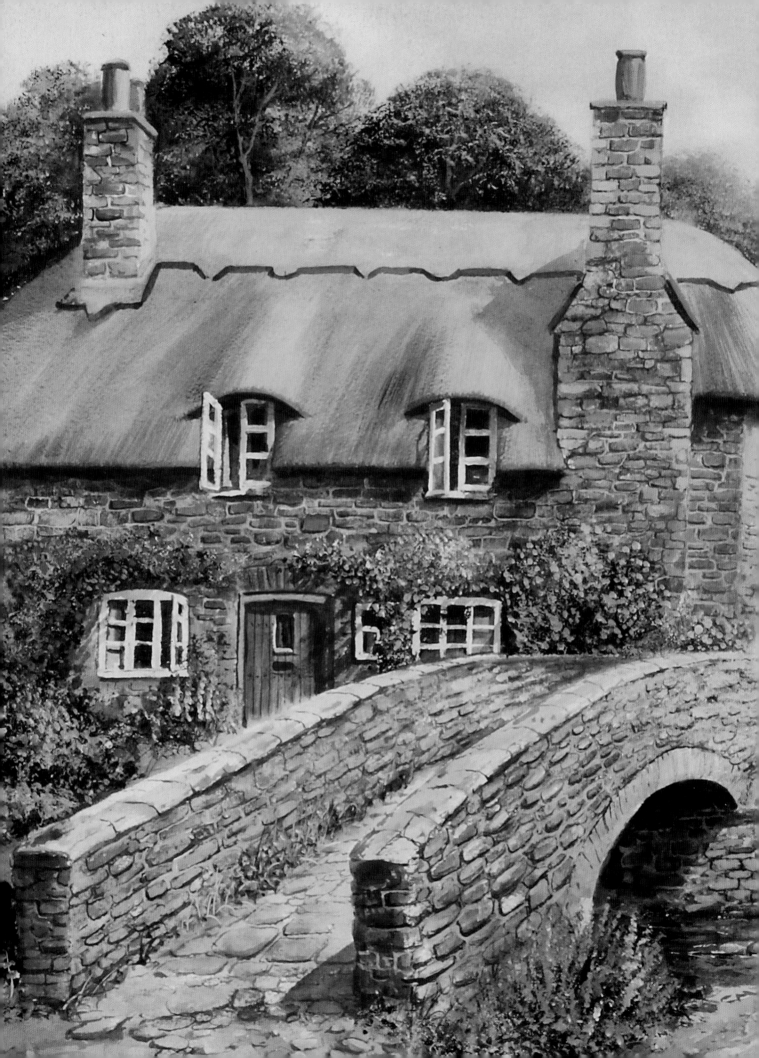

CHOOSING YOUR EQUIPMENT

Materials

Paints

Acrylics are extremely versatile, and can be used for oil painting techniques, in a watercolour style, or a combination of the two. They dry much faster than oils, and cannot be lifted out once they have dried. Unlike watercolour paints, they dry a little darker than when you first apply them.

Acrylic paints can be bought in tubes or jars. I prefer the tube paints, which have a buttery consistency like oils. They can be thinned down with water for some techniques, or used straight from the tube for a more textured 'impasto' style.

There are students' and artists' quality paints. I prefer the artists' quality paints, as the colours are more brilliant and the range is wider.

A range of artists' quality acrylic paints in tubes.

Mediums and additives

Acrylic paints can be mixed with mediums, which are liquid gels or pastes, to create different effects. There are mediums to speed up drying time, and to slow it down. Flow improver increases the workability of the paint. Mediums can create a gloss, matt or iridescent finish, and an impasto gel can be used to make brush strokes or knife marks visible. In this book, I have used glaze medium mixed with paint to create a transparent glaze over dried paint in scenes where I wanted a shaft of light through trees or a layer of mist.

Texture pastes can be used with acrylic paints to create textured effects. I have applied texture paste with a brush or a painting knife to suggest the rough surface of cliffs and rocks, but also for finer effects such as surf, sea spray and grasses.

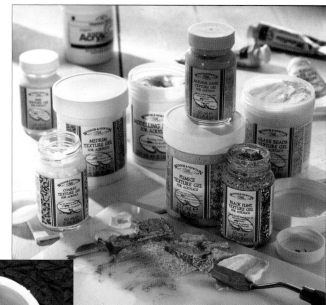

A selection of mediums and additives and (left) texture paste.

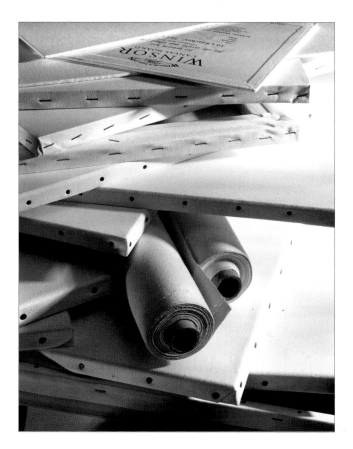

Surfaces

You can stretch your own canvases or buy them ready stretched. If you are new to acrylics, it might be best to begin with canvas boards, which are cheaper and can be cut to the size you need. The demonstrations in this book were all done on canvas boards.

Acrylic paints can also be used on heavy watercolour paper; I use 300gsm (140lb) Rough paper as it is unlikely to cockle when wet. You can prime the paper with glaze medium or gesso first, so that the acrylic paint does not sink into the surface. You can also apply texture paste to watercolour paper if you want to work on a textured surface.

Rolls of canvas, stretched canvases and canvas boards.

Other materials

2B pencil
This is used for drawing the scene on to your surface.

Paper mask
You can make a paper mask from spare watercolour paper and use it to mask off areas while you paint. I have used a paper mask to help me paint hedgerows, horizons and roof edges in this book.

Hairdryer
This can be used to speed up the drying process.

Masking tape
This can be used to attach watercolour paper to your painting board.

Ruler
This is used to help you paint straight lines, particularly when painting architectural details.

Kitchen paper
You can use this to mop up spills, to remove excess paint or water from brushes, and to clean brushes and painting knives.

Bucket
You need to clean brushes well when using acrylic paints, and for this you need plenty of water, so I rinse my brushes in a bucket. Brushes should be rinsed immediately after use, or the paints will dry on the brushes and ruin them. When you finish painting, wash the brushes under running water.

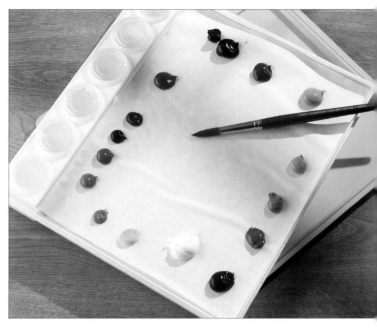

Stay-wet palette
This is essential to prevent acrylics from drying out. It is a plastic tray with an absorbent material in the base that you keep wet, then a disposable sheet of greaseproof paper on which you lay out your colours. Put on the tight-fitting lid when you finish painting, and the paints will remain moist.

Painting knives
These have a handle with a cranked shaft and are used for applying paint on to your painting. Palette knives are attached to the handle with a flat shaft, and are used for mixing paint on the palette. It is good to have a selection of painting knives in different shapes and sizes.

Tracedown paper
Acrylics are opaque and you can find that you have obscured your drawing when you still need it. Keep a tracing of the important parts and use tracedown paper to re-establish the drawing.

Water mister
This can be used if you are painting outside or for long periods, to keep the acrylic paints moist.

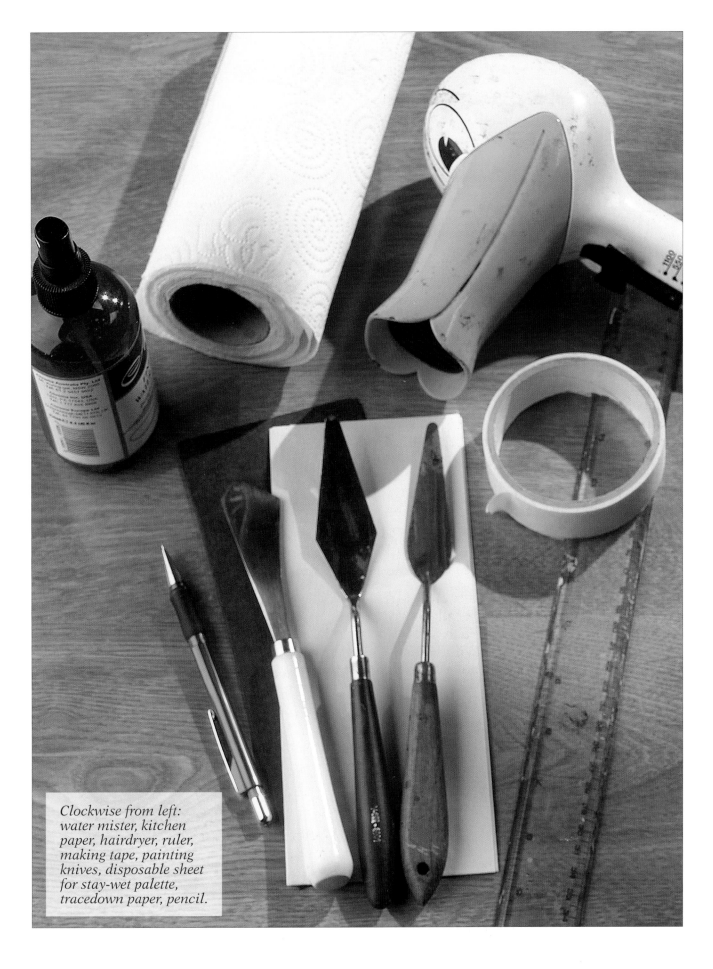

Clockwise from left: water mister, kitchen paper, hairdryer, ruler, making tape, painting knives, disposable sheet for stay-wet palette, tracedown paper, pencil.

My palette

The selection of colours I use in my palette is not based on any technical or traditional formula. It is a very personal choice, using colours that are readily available in most stores. I am not an artist who deliberately uses a limited palette of only a few colours – why restrict yourself when there are so many wonderful colours out there to be explored? Having said that, I don't use a huge number of colours.

All the paintings in this book were painted using the same palette; this is my selection which I think covers most eventualities. I use two blues: ultramarine and cobalt blue and usually two reds: cadmium red and permanent rose. Sometimes I use alizarin crimson instead, but I find it a little dull and it lacks the freshness of permanent rose. The earth colours in my palette are yellow ochre, raw sienna, burnt sienna and burnt umber. The one yellow is cadmium yellow.

I am a great believer in ready-mixed greens; they simply make painting easier. I used Hooker's green, olive green and pale olive green for the paintings in this book. Lastly of course, there is titanium white. I use plenty of white, so I would recommend buying it in larger tubes for economy. The white is mostly used for lightening the other colours.

The colours I use

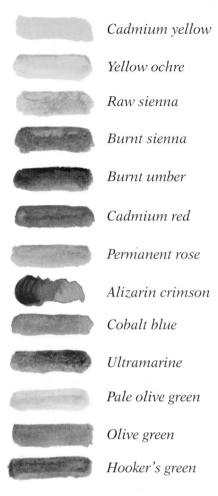

Cadmium yellow

Yellow ochre

Raw sienna

Burnt sienna

Burnt umber

Cadmium red

Permanent rose

Alizarin crimson

Cobalt blue

Ultramarine

Pale olive green

Olive green

Hooker's green

My stay-wet palette (below) set out ready for painting with my usual range of colours, and (left) during a painting session with the paints used and mixed.

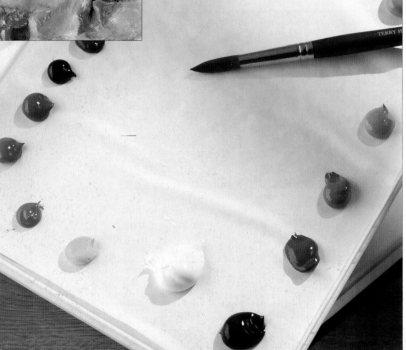

Opposite: In the Clearing
Autumn is a colourful time of year; bright golds and yellows mixed with oranges and reds make a fabulous contrast after painting the greens of summer. In this painting I have tried to capture the bright sunlight in this New Forest clearing. The top and the bottom of the painting are quite dark, which contrasts strongly with the central light area, making it appear brighter. The pony is framed by the trees in the background, as if the viewer has suddenly stumbled across a clearing in the wood.

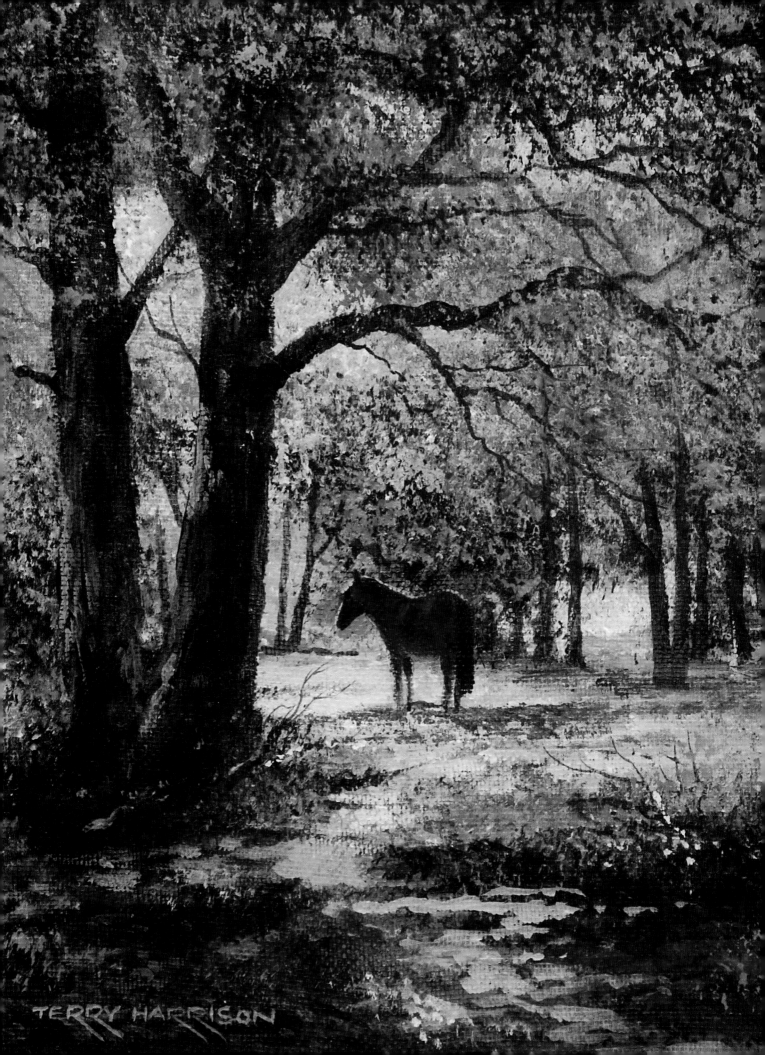

Colour mixing

Acrylics have a bit of a reputation for being bright and garish, but I find with a bit of colour mixing they are fine. Paint used straight from the tube is always going to be full strength, so some colour blending is necessary to achieve the colour you are looking for.

Ready-mixed greens seem to cause the most problems, as most colours are bright and unnatural looking. To tone down bright greens I add a warm red-toned colour such as burnt umber or burnt sienna. The reds in the mix calm down the greens and make them more suitable for landscape painting.

Mixing with white
Adding white to a colour will lighten the tone, it will also make a transparent colour opaque.

Cobalt blue and pale olive green mixed with white is a good misty distant colour.

Raw sienna mixed with Hooker's green and white will make a soft, warm olive green.

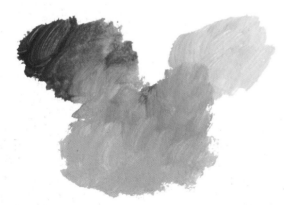

Cobalt blue mixed with permanent rose and white is a good mix for painting bluebells and wisteria.

Ultramarine mixed with Hooker's green and a varying amount of white is a simple mix when painting water and the sea.

Mixing greys

Greys and blacks should be mixed. To keep this simple, if you mix a blue with a brown, you will get a grey colour. For example, burnt sienna and cobalt blue will result in a mid-tone grey. If you mix two dark colours such as ultramarine and burnt umber, the mix will appear almost black.

Raw sienna and cobalt blue will blend to a cool grey; adding white will lighten the grey.

Burnt umber mixed with ultramarine makes a dark, warm, almost black colour. Add white to this colour to mix a wide range of greys.

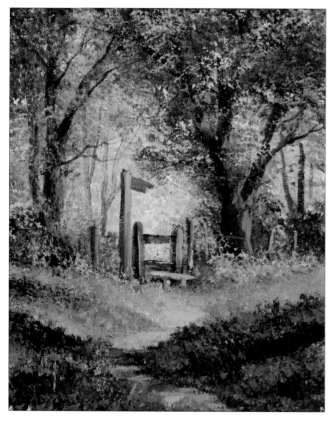

Bluebell Wood

I used a mix of pale olive green and cobalt blue with white for this background, and for the trees and foreground I used a mix of Hooker's green, pale olive green, burnt umber and white. The stile and tree trunks are a mix of burnt umber and Hooker's green with white. The bluebell mix is cobalt blue and permanent rose with added white.

Rocks at Sea

Only two brushes were used in this painting: the medium detail brush and the golden leaf. Only two colours were used to create the water: Hooker's green and ultramarine, with varying amounts of white. The sky is ultramarine toned down with white. The rocks were painted using a painting knife and mixes of raw sienna, burnt umber and ultramarine for the darks, adding white to create the greys.

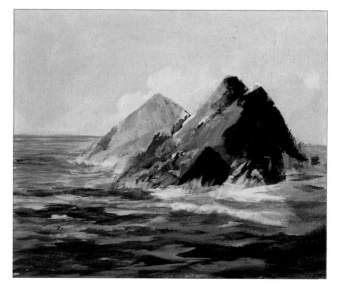

Brushes

Most artists adapt or customise standard brushes to suit their particular needs. After years of trying to get what I want out of brushes, I have gone one step further and developed a range of my own, already customised to do the job perfectly. The brushes featured in this book are part of that range, and are designed to help you to achieve the best effects for acrylic painting with the minimum of effort.

Golden leaf

This 2.5cm (1in) brush will hold a great deal of paint or water, so is ideal for painting big washes, for skies or water, as you do not need to reload it too often. It can also be used with stippling and flicking techniques to paint trees, bushes and foreground leaves. The brush is made from bristle blended with fine, natural hair. The stiffness of the bristles makes it ideal for acrylics. When the hair is wet, it curls and keeps the bristles separate, so it is well suited for painting texture.

Foliage

This is a smaller version of the golden leaf. It is designed to help you produce foliage and other textures by stippling over the surface of the paper with the stiff bristles. Use it to paint trees, bushes, hedgerows and woodland floors as well as texture on buildings, footpaths, walls and roads.

Wizard

This is made from a blend of natural hair, twenty per cent of which is slightly longer than the rest. The paint is held by the body of the brush and released through the longer hair, which forms small points to produce fine lines. These can be used to suggest grasses, woodgrain or certain trees. The wizard is also good for blending water and reflections.

Fan stippler

This stippling brush has a blend of hair and bristle which helps you to create a range of different textural effects with acrylics. It is useful for mimicking nature and the shape makes it especially good for trees.

Fan gogh

This brush is made from a blend of natural hair and is thicker than many other fan brushes, so it holds plenty of paint and does not separate. It can be used for a wide range of trees and for grasses, as well as for textures like fur. Fan brushes were originally invented for blending techniques used with oil paints, and the fan gogh is ideal for this purpose, for instance when painting skies or reflections.

Stippler px

This brush uses the same hair combination as the foliage and fan stippler brushes, and is useful for stippling to create foliage and other textures. The stiff bristles can also be used to apply texture paste before painting with acrylics, though the brush must be washed out quickly afterwards. The px refers to the clear acrylic resin handle, which has an angled end and is used for scraping out paint to create stone walls, tree trunks and many other effects.

19mm (¾in) flat

This flat brush is made from synthetic hair. This provides the spring and helps to keep the shape. It is good for blocking in large areas, and the straight edge makes it useful for painting horizons and buildings. It is ideal for water, reflections and ripples.

13mm (½in) flat brush

Like the Emperor, this smaller flat brush is useful for blocking in areas of colour and for creating ripples and reflections.

Half-rigger

This brush is shorter than an ordinary rigger, which makes it easier to control. It is made from synthetic material and is designed to keep its point and shape. It is useful for painting grasses and flowers and of course for painting the rigging on boats! Fully loaded, this brush will hold enough paint to complete a long, unbroken line.

Small detail

Detail brushes, as you might imagine, are usually used when painting detail! This type of brush is also known as a round, and I find that three sizes – small, medium and large – give me plenty of scope. The small detail brush is best for refining and sharpening up sections of your painting and, of course, adding your signature to the finished picture.

Medium detail

The medium detail is the workhorse brush – it is the one you reach for before trying any of the other detail brushes. It will go to quite a fine point, and is suitable for adding all but the finest detail to a painting.

Large detail

The large detail brush is extremely versatile. It can be used to add a determined statement to a painting; it holds a lot of paint yet will still go to quite a fine point. It can also be used for washing in skies.

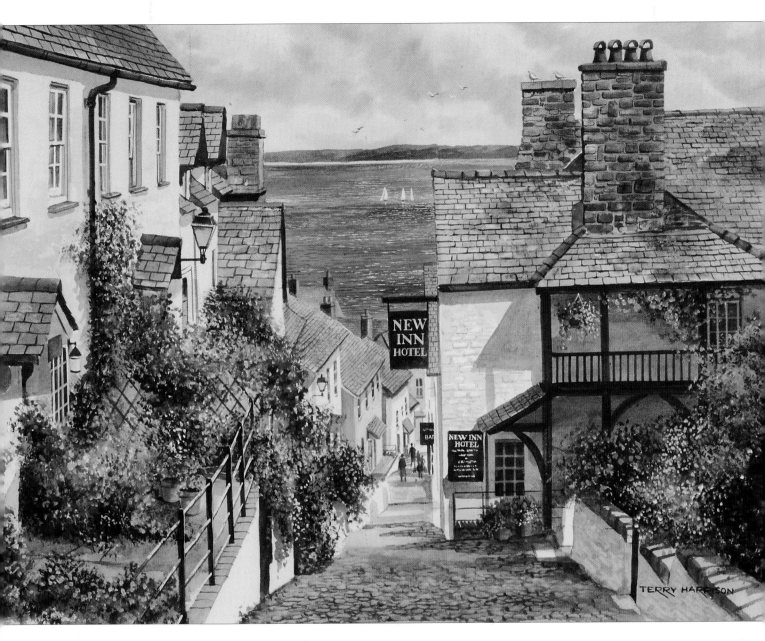

Sea View, Clovelly

This is a very detailed painting of Clovelly, on the north coast of
Devon. Time and patience were needed to create the fine detail on the
slate roofs and cobbled street, for which I used the half-rigger. The
mass of foliage and flower textures were created using the foliage
brush, and the flower heads were dotted on top using the medium and
small detail brushes.

USING THE BRUSHES

Hot Day, Cool Waters

To capture the light in this painting, it is important to have plenty of darks. It is the contrast between lights and darks that creates the sunlight in the painting. The feeling of depth is achieved with the use of light and dark as well as colour. The darks and shade of the foreground lead you downstream to the light blue, hazy distance of the bend in the river. The mood of the painting is captured by colour but using different types of brushes created the texture: the dense foliage of the trees on the opposite bank was stippled using the golden leaf brush. Using the same brush, the water and reflections were painted using bold downward brush strokes. The medium detail brush was used to paint the tree trunks and some of the ripples in the water, and the 13mm (½in) flat brush was used to create some of the ripples and

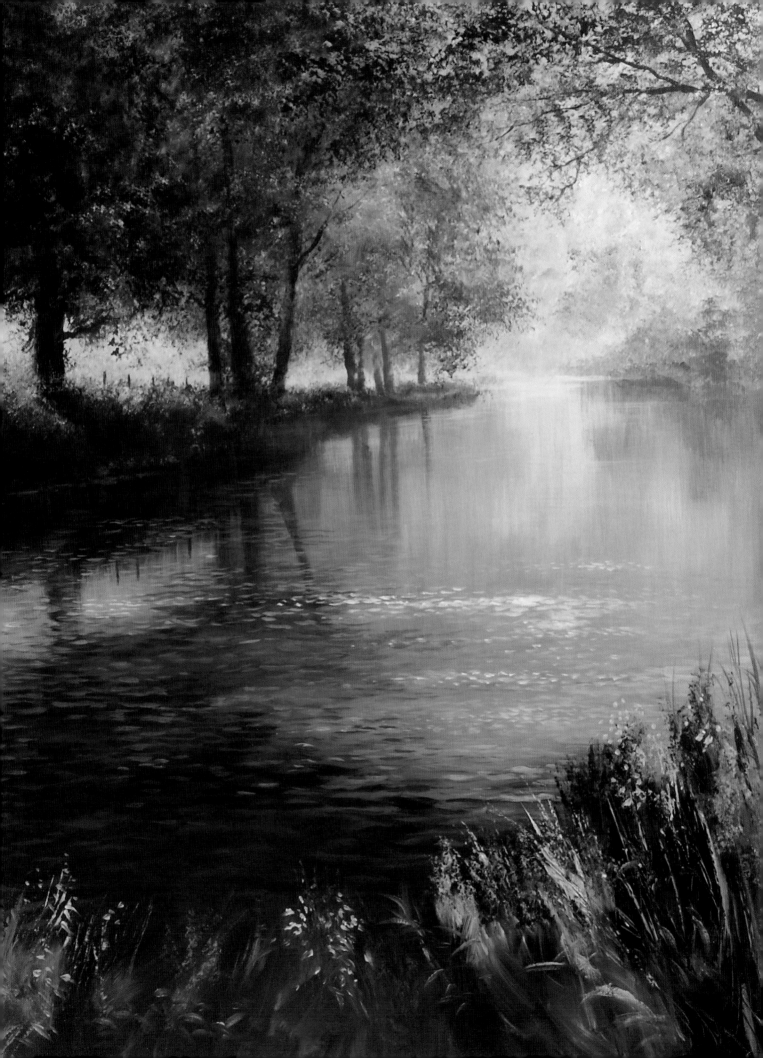

Golden leaf

When this brush is new, dip it in hot water so that the hair curls, as this will keep the bristles separate, making the brush ideal for creating texture. As its name suggests, it is perfectly suited for stippling foliage in landscapes, and it can also be used for flicking up grasses. Do not overload the brush when stippling, or the texture will be lost in a flat wash. To avoid this, squeeze the brush between your fingers or dab it on kitchen paper. Because of its size and the fact that it holds lots of water, this is also an excellent brush for laying large washes such as skies.

Ivy-covered tree

1. Stipple on the ivied trunk shape of the tree with Hooker's green on the golden leaf brush.

2. Mix olive green with Hooker's green and stipple on the tree's foliage. Allow to dry.

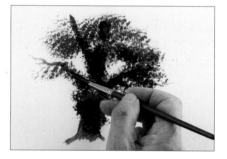

3. Change to the medium detail brush and paint the branches and trunk with a mix of Hooker's green and burnt umber.

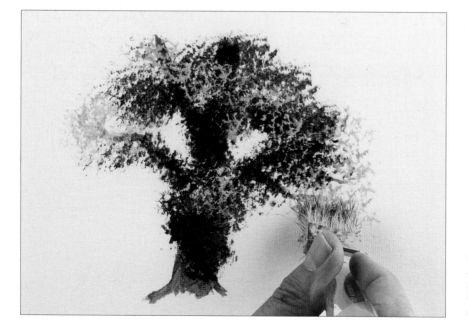

4. Use the golden leaf brush to stipple highlights for sunlit leaves with pale olive green and white.

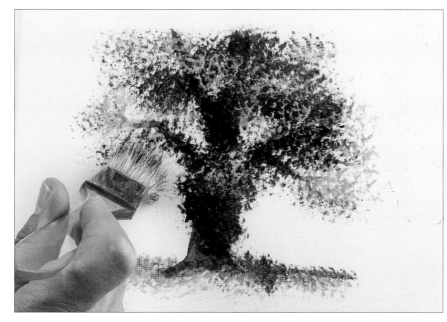

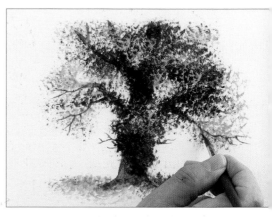

6. Finally add more branches with the medium detail brush and Hooker's green with burnt umber.

5. Mix olive green and Hooker's green. Stipple the ground beneath the tree and flick up grasses, then add mid-tones to the foliage.

The finished tree.

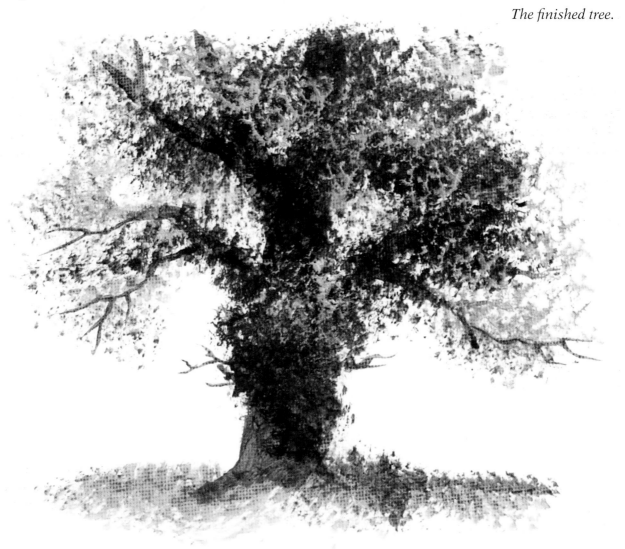

Foliage

This is a smaller version of the golden leaf brush, and is good for painting natural textures such as foliage or blossom, as shown here. It can also be used to create the white foam on waves, or the texture of buildings. Do not overload the foliage brush with too much paint, as this will flood the surface and the texture will be lost.

Blossom

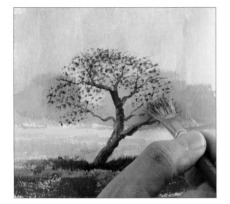 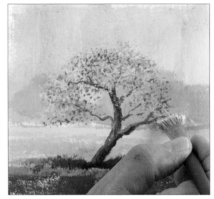 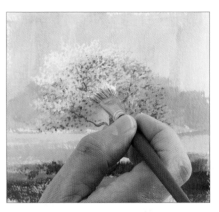

1. Here I have already painted the background and then the trunk and branches with Hooker's green and burnt umber, and allowed this to dry. Dilute the same mix and use the foliage brush to lightly stipple spring foliage.

2. Mix white with permanent rose, and stipple this on to the tree to create blossom.

3. Add more white to the mix and stipple the sunlit side of the tree.

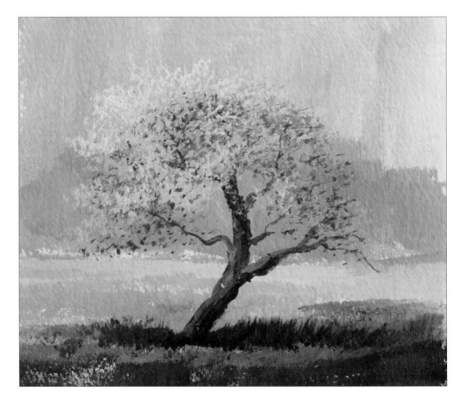

The finished tree.

Waves and foam

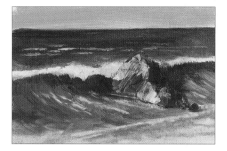

1. Here I have painted the scene and allowed it to dry.

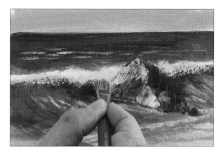

2. Use the foliage brush with white and cobalt blue, making sure it is not too wet, to stipple the underside of the cresting wave.

3. Make a paper mask to cover the rock, then stipple foam crashing up around the rock with the same mix.

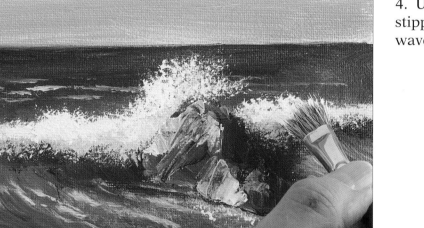

4. Use neat white paint to stipple more foam over the wave to finish the effect.

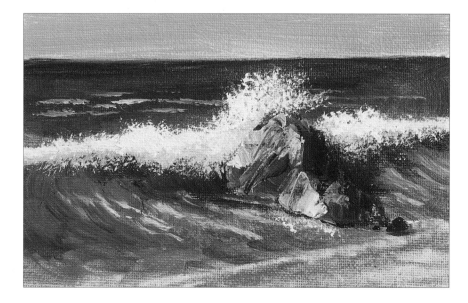

The finished painting.

Buildings

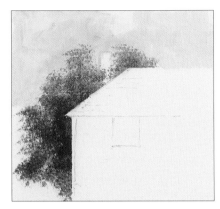

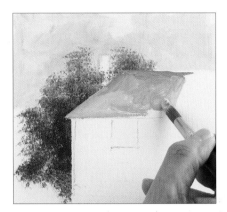

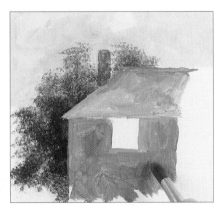

1. I first painted in the sky with cobalt blue and white, then used a paper mask to protect the building shape and used the foliage brush to stipple foliage with a mix of Hooker's green and olive green.

2. Use the large detail brush to block in the slate roof with ultramarine, burnt umber and white.

3. Paint the brickwork with burnt sienna, ultramarine and a little white. Allow to dry.

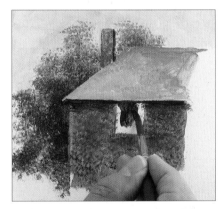

4. Mix pale olive green, yellow ochre and white and use the foliage brush to stipple lichen on the roof, protecting the foliage with a paper mask.

5. Mask the roof with paper and stipple a mix of burnt sienna and ultramarine on the brickwork.

6. Use the medium detail brush and a mix of ultramarine and burnt umber to shade the right-hand side of the chimney and under the eaves, and to block in the window.

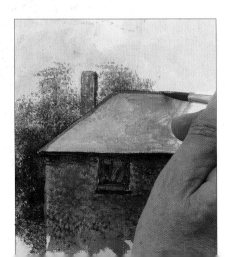

7. Paint the ridge tiles along the top and the left-hand side of the roof with burnt sienna and allow to dry.

The finished building. The window frame was added with the half-rigger and white paint.

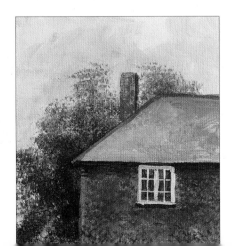

Welcome Delivery

The foliage brush played a big part in the success of this painting; not only was it used on the trees and foreground foliage but also for the texture on the roofs and buildings. The surface of the road was also painted with the foliage brush by stippling texture over the surface, which gives the impression of lots of detail, with very little effort.

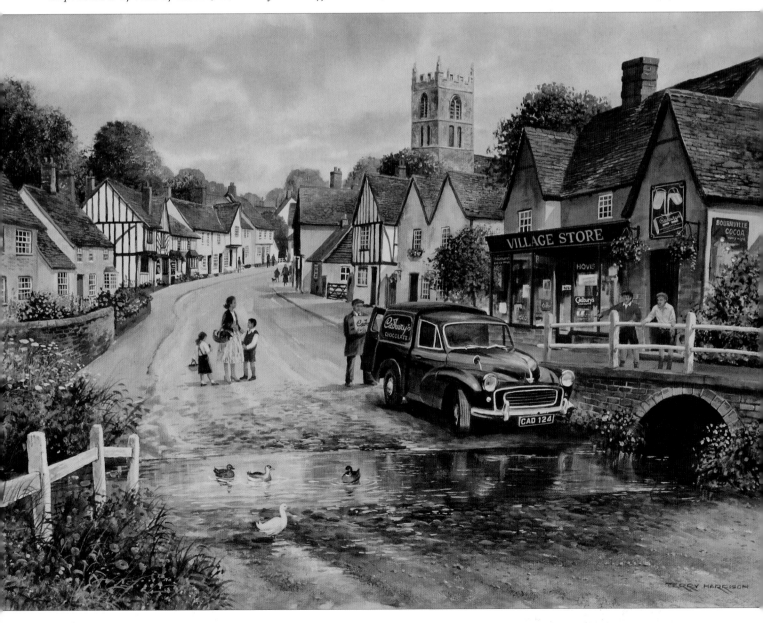

Wizard

With its hair of two different lengths, the wizard can be used to create a variety of effects. Used with more pressure, it produces a solid brush stroke or a wash, but used with only light pressure, it creates a streaked brush stroke. It is useful for creating grasses, reflections, woodgrain, fast-running water and other streaked effects.

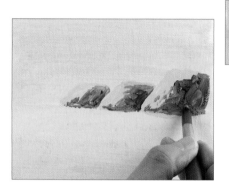 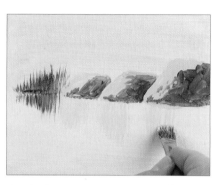 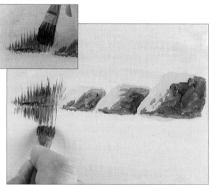

1. Paint the sky and water with the large detail brush and a mix of cobalt blue and white, and the rocks with raw sienna and white, then paint the darker parts and the texture with burnt umber and ultramarine.

2. Use the wizard brush with Hooker's green to flick up grasses. Drag the brush down to create reflections.

3. Paint raw sienna and white beneath the rocks and drag this down into the water.

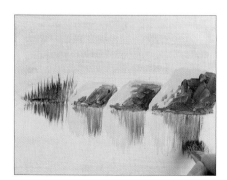

4. Add a mix of ultramarine and burnt umber and use the wizard brush to drag this down to create reflections of the darker parts of the rocks.

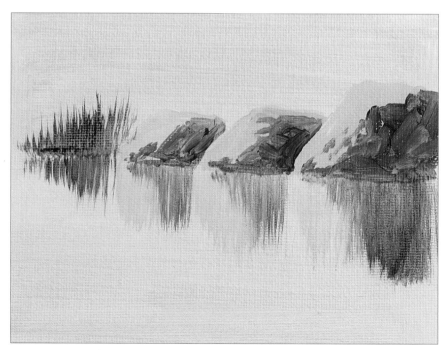

The finished reflections.

Gum tree

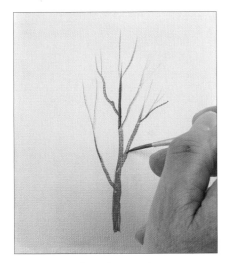 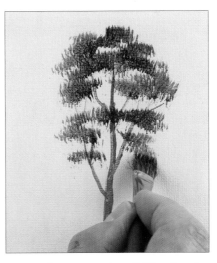 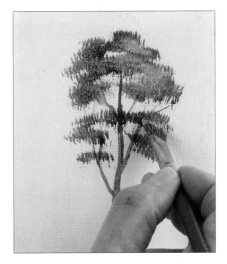

1. Paint the sky with cobalt blue and white, and then paint the trunk and branches with the half-rigger and burnt umber with ultramarine.

2. Pick up a mix of Hooker's green and ultramarine on the wizard brush and paint short downward stokes to create the foliage of the gum tree.

3. Mix olive green with pale olive green and white and paint highlights on the foliage, and grass underneath the gum tree.

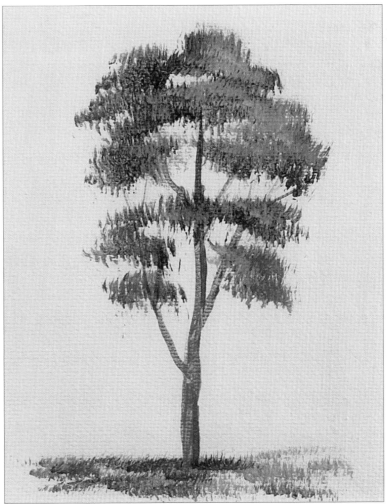

The finished gum tree.

Woodgrain

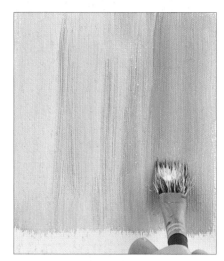

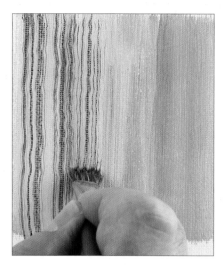

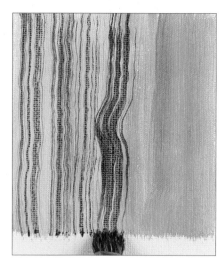

1. Block in the background of the wood with raw sienna, burnt sienna and burnt umber, painting in the direction of the woodgrain with the wizard brush. Allow to dry.

2. Make a watery mix of ultramarine and burnt umber so that it flows through the brush, and hold the brush upright with the tip down to paint the woodgrain. Wiggle the brush for a natural look.

3. Take the brush over to the left in the middle of a downstroke to create a knot in the wood.

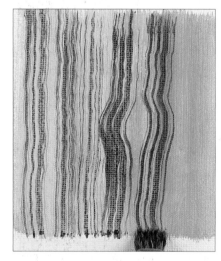

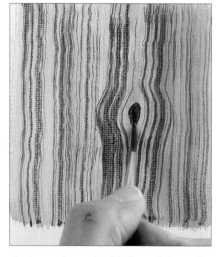

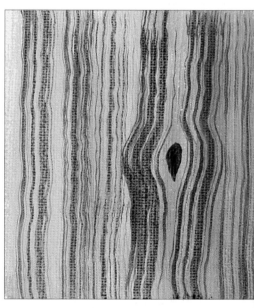

4. Take the next downward brush stroke over to the right to create the other side of the knot in the wood.

5. Use the small detail brush and the same ultramarine and burnt umber mix to paint the centre of the knot.

The finished wood.

*Opposite: **The Woodshed Door***
The woodgrain effect on this door was achieved using the wizard brush, and I added fine detail and tidied up using the half-rigger. I used a limited palette of burnt umber, burnt sienna, raw sienna, ultramarine and white.

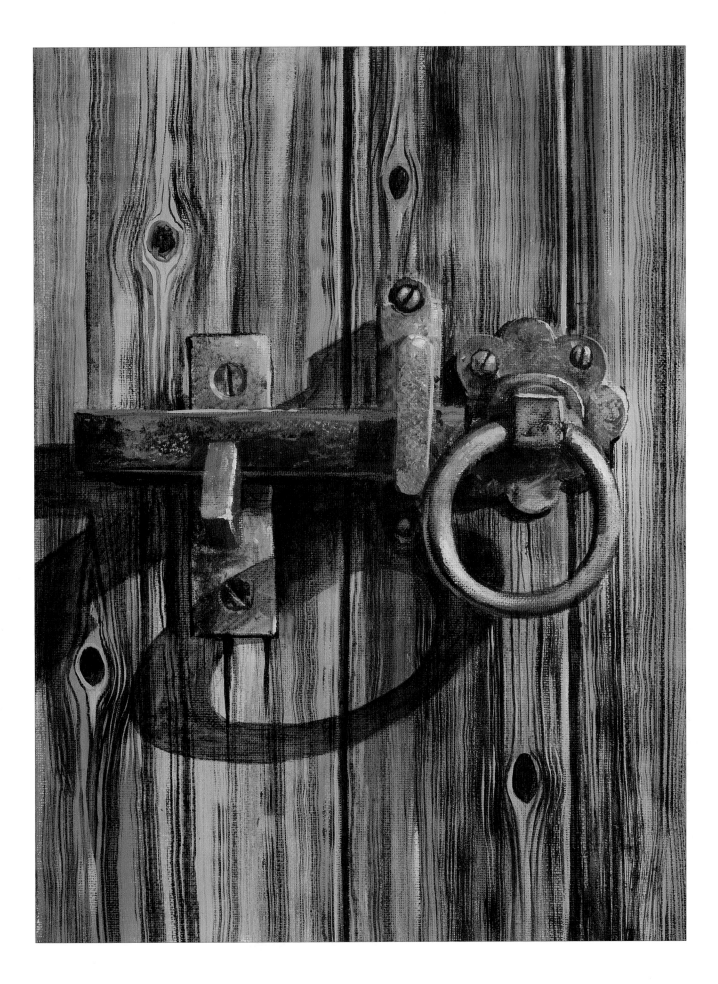

Fan stippler

This fan-shaped brush has stiff hairs, making it good for stippling, either lightly for a fine texture or firmly to create more dense texture. This and the shape of the brush make it ideal for painting trees, and for creating and highlighting clumps of foliage, as in a hedgerow. You can also use it to add a dusting of stippled snow to winter trees once they have dried. Held on its side, it can be used to paint various plants such as bluebells and other wild flowers.

Winter trees

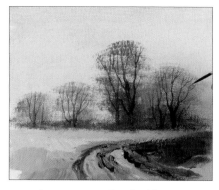

1. Having painted the background and allowed it to dry, paint the winter trees with a mix of burnt umber, ultramarine and white. Push the fan stippler into the paper to create the tree shapes.

2. Use a slightly darker mix at the base of the trees to create a hedgerow.

3. Change to the half-rigger and use a still darker mix to paint trunks and branches into the stippled areas.

The finished winter trees.

4. Use the fan stippler with a mix of raw sienna and white to paint highlights in the foliage.

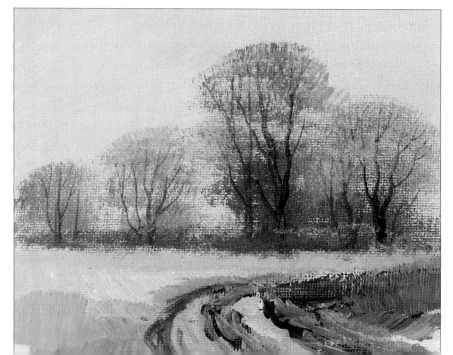

Adding snow to a scene

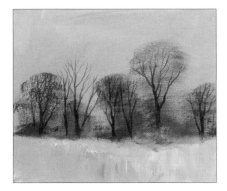

1. Paint this scene in a similar way to the one on the facing page.

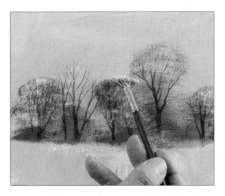

2. Pick up white and cobalt blue with the fan stippler and stipple it on to the tree tops.

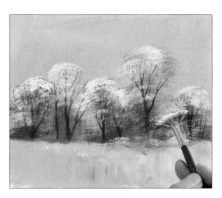

3. Next use white on its own to highlight the snow in the trees.

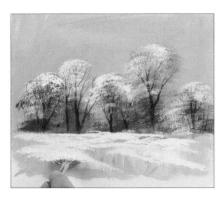

4. Add snow to the ground with sweeping motions of the fan stippler, implying the shape of the snowy ground.

5. Paint snow on the branches using the half-rigger and white.

The finished snow scene.

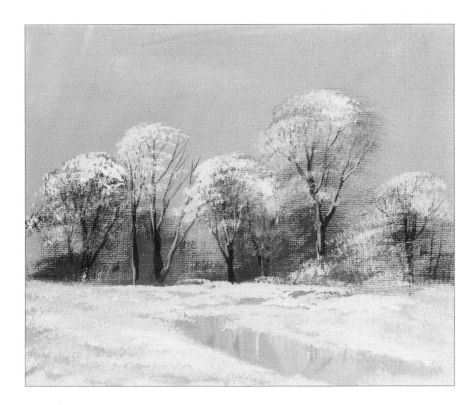

Hedgerow

1. Paint sky and allow it to dry, then stipple the bushes in the hedgerow with Hooker's green and olive green.

2. Flick up a mix of pale olive green and white for the grass in front of the hedgerow.

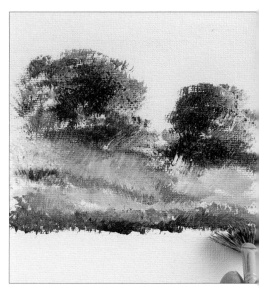

3. Paint darker grasses in the foreground with Hooker's green and olive green.

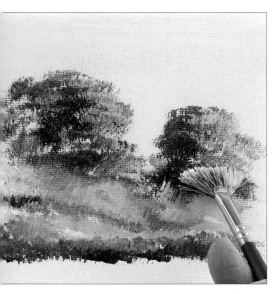

4. Mix white, pale olive green and cadmium yellow and touch in highlights in the foliage.

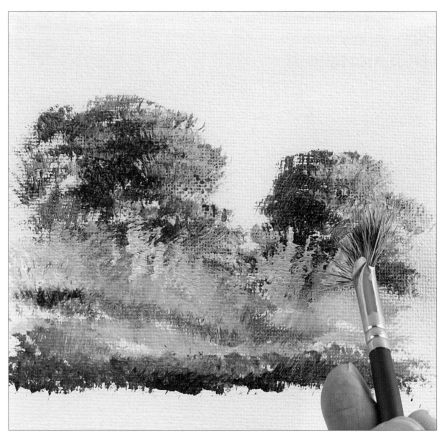

5. Use the fan stippler on its side with a mix of cobalt blue, permanent rose and white, to suggest wild flowers.

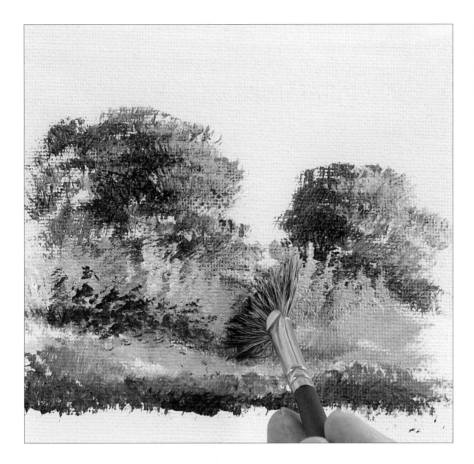

6. Still using the brush on its side, stipple on the shapes of plants in front of the hedgerow with Hooker's green.

The finished hedgerow.

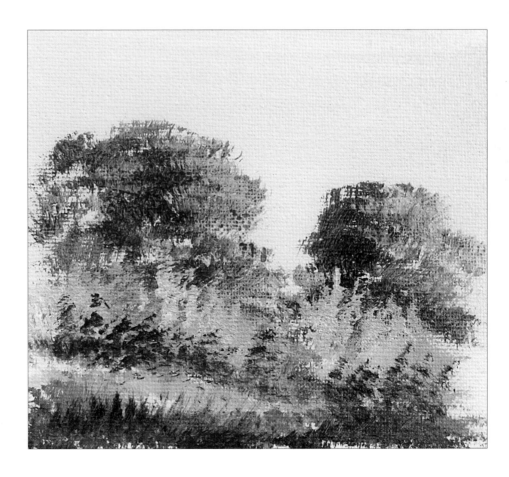

37

Fan gogh

The fan gogh has a thick head of hair, and even when it is wet, the hairs don't separate as they do with thinner fan brushes. It is an excellent shape for painting trees and clouds, and the soft hairs make it good for blending, but it has plenty of spring so that it can be used with acrylic paints.

Blending for skies

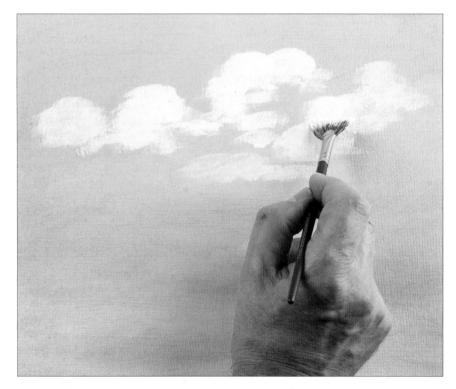

1. Paint the blue of the sky with cobalt blue and white, and allow to dry. Use the fan gogh brush to paint clouds with white.

2. While the white paint is wet, mix ultramarine and burnt umber and paint the darker parts of the clouds. Use the soft hairs of the brush to blend in the darker colour with the white.

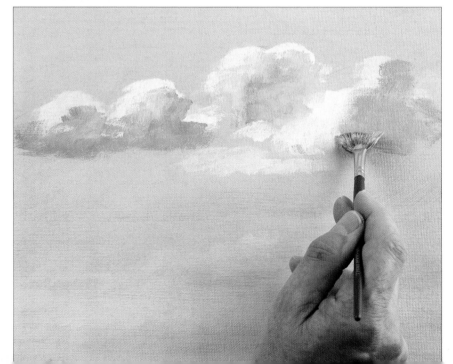

3. Wash the brush and pick up white paint again, then re-establish the highlights in the clouds, and once again, blend this in with the darker colour.

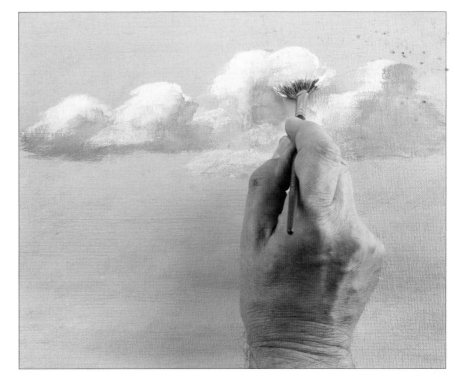

The finished clouds.

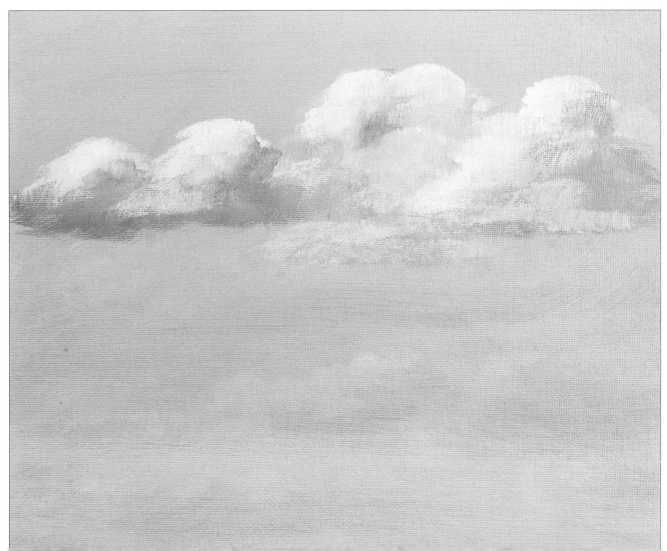

Norway spruce

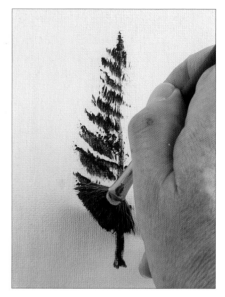

1. Paint the trunk with burnt umber and Hooker's green, then hold the brush vertically and paint the pointed top of the tree with Hooker's green.

2. Tilt the brush forty-five degrees and flick up foliage to create the spruce's branches.

3. Continue down the trunk, making the branches wider as you descend.

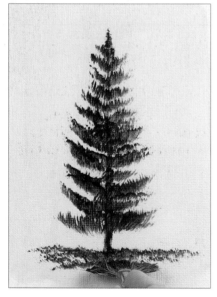

4. Paint the branches on the other side in the same way, then flick up grass under the tree to give it something to stand on.

The finished Norway spruce.

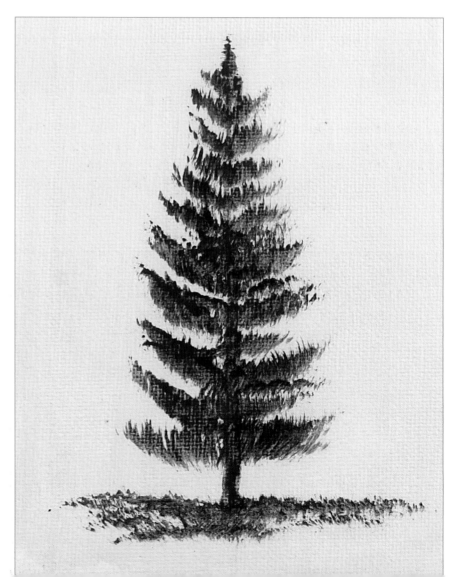

Fir tree in a landscape

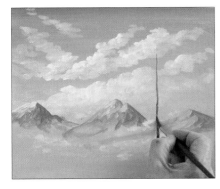

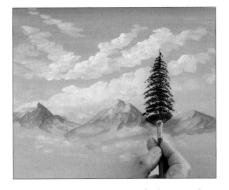

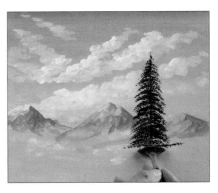

1. Once the background has dried, use the medium detail brush to paint the trunk with burnt umber and Hooker's green.

2. Use the shape of the end of the fan gogh brush to create a downward sloping curve for each branch, with Hooker's green.

3. Paint the branches on the other side of the tree in the same way, then use the tip of the brush to flick up a little foliage under the tree.

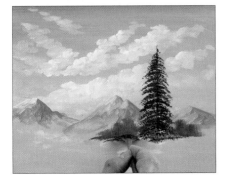

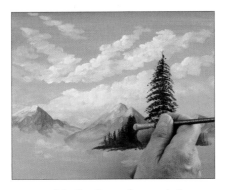

4. Mix Hooker's green with cobalt blue to imply distant trees behind the main tree.

5. Hold the brush upright and use a darker mix of Hooker's green and cobalt blue to suggest the pointed shapes of distant trees.

6. Mix pale olive green, yellow ochre and white to paint the ground in front of the tree.

The tree in a partly finished painting.

41

Scots pine

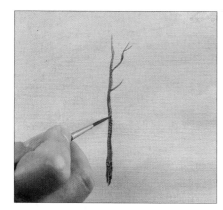

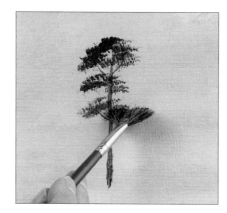

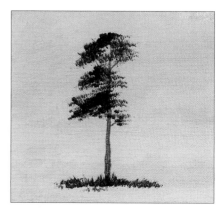

1. Use the half-rigger and burnt umber to paint a trunk and sparse branches. Scots pines often have few branches, especially lower down.

2. Pick up Hooker's green and use the corner of the fan gogh brush to touch in clumps of foliage.

3. Use the ends of the bristles to flick up a little grass beneath the tree.

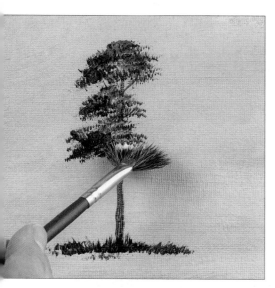

4. Mix Hooker's green with a little cobalt blue and white and stipple on highlights.

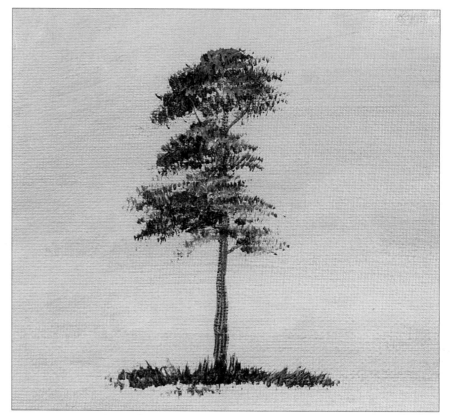

The finished Scots pine.

Cedar

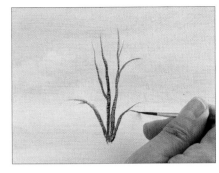

1. Use the medium detail brush to paint the trunk and branches with burnt umber and Hooker's green.

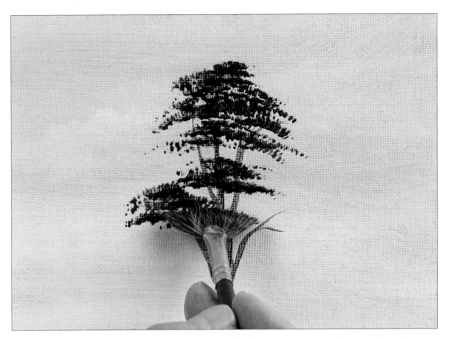

2. Touch in foliage with a mix of olive green and Hooker's green, using the shape of the brush to create downward sloping curves.

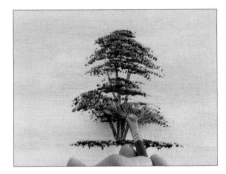

3. Paint grass at the base of the tree with the same mix.

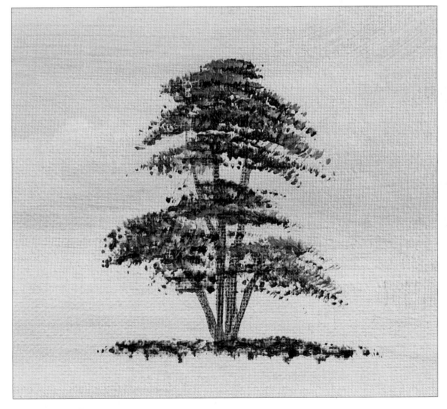

The finished cedar.

43

Stippler px

The stippler px, as its name suggests, has stiff hairs which are good for stippling texture with acrylics. After picking up paint, tap the brush on to a flat surface to splay the hairs. Stipple by tapping the brush up and down on the paper. The px part of the name refers to the clear plastic handle with a sloping cut-away end which is used as a scraper. This can be used to scrape out textures such as bark, stones, or pebbles. The brush can be used to apply texture paste, and the handle to create added texture in it.

Scraping out bark texture

1. Block in the tree trunk and branch with pale olive green and the large detail brush.

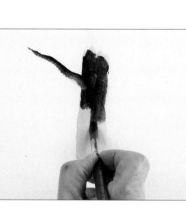

2. Paint a thick mix of Hooker's green and burnt umber on top of the light colour.

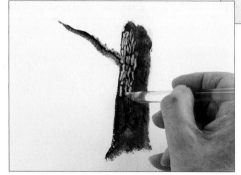

3. Use the specially shaped acrylic resin handle to scrape out texture in the wet paint.

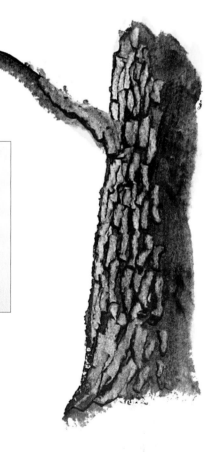

The finished tree trunk.

Scraping out a stone wall

1. Use the brush of the stippler px to paint on a thick mix of yellow ochre and pale olive green.

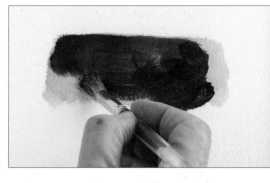

2. Paint a dark mix of Hooker's green and burnt umber on top.

3. Use the shaped end of the handle to scrape out stone shapes with a sideways motion.

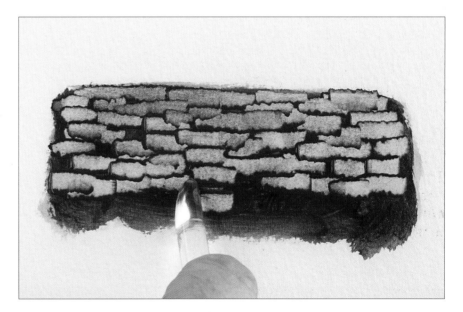

The finished stone wall.

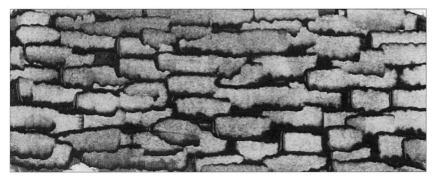

Scraping out pebbles

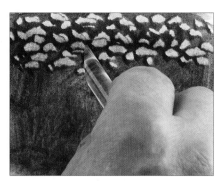

1. Use the brush end of the stippler px to paint cobalt blue at the top of the area, and yellow ochre at the bottom.

2. Paint a thick, dark mix of ultramarine and burnt umber over the whole area.

3. Use the shaped handle end of the stippler px to scrape out pebbles from the top downwards, making them smaller in the background.

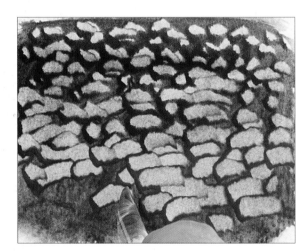

4. Continue scraping out pebble shapes, making them larger lower down.

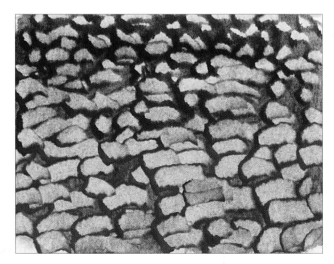

The finished pebbles.

Applying texture paste

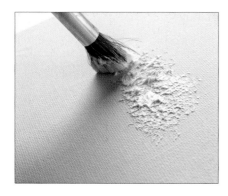

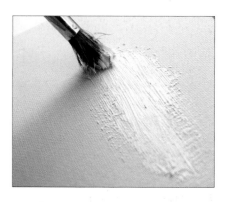

You can use the stippler px to stipple on texture paste, creating a thick, raised texture as shown.

You can also use the brush to create a streaked texture.

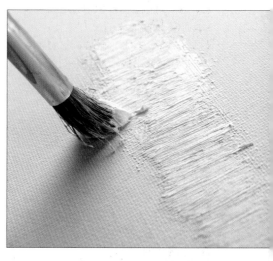

Use horizontal brush strokes to create the texture of grasses.

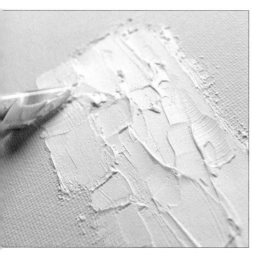

Once the texture paste is applied, the shaped handle end can be used to create texture. This effect could be used to suggest plastered buildings.

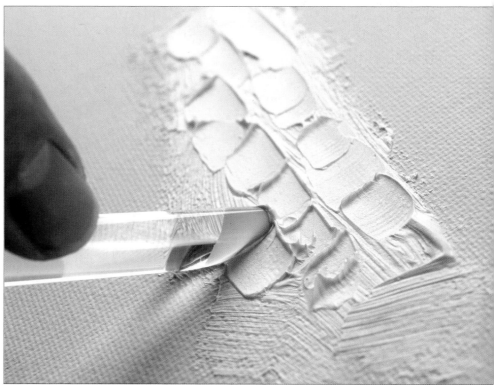

You can vary the texture created with the px handle.

13mm (½in) flat

Like the larger 19mm (¾in) flat, this brush is good for creating ripples and reflections, as well as for blocking in areas of colour. Its size makes it more controllable if you are working on a slightly smaller scale.

Rippled water

Pick up cobalt blue and use the flat edge of the brush to create ripples with a side-to-side motion.

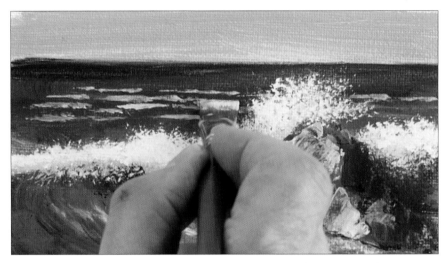

Here, the seascape has been painted and allowed to dry, then the 13mm (½in) flat brush is being used to create ripples on the dark part of the sea with a light mix of white and cobalt blue.

Rocks, reflections and ripples

1. Use the 13mm (½in) flat brush to block in the rock shapes with pale olive green.

2. Paint a thick mix of burnt umber and ultramarine on top of the lighter colour.

3. Use a plastic card such as an old credit card to scrape out texture, creating further rock shapes within the main shape.

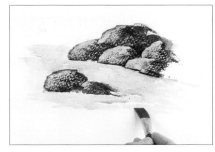

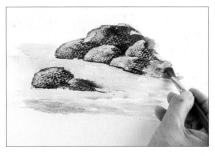

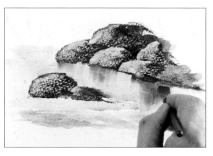

4. Paint the water with a mix of cobalt blue and white, and create ripples at the front, leaving some white paper.

5. Paint a little greenery at the water's edge with Hooker's green and white.

6. Pick up burnt umber and ultramarine and drag this down into the water to create reflections.

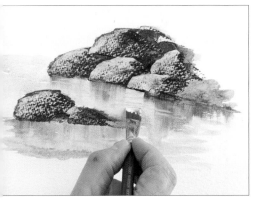

7. Drag down reflections for the foreground rock too. Pick up a dry mix of white and pale olive green and use the flat edge of the brush to create ripples over the dark reflections.

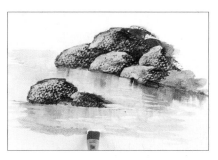

8. Paint ripples in the foreground with pure white.

The finished scene.

19mm (¾in) flat

This brush has many uses such as painting water, reflections and ripples. It is ideal for tackling buildings and subjects with straight edges, and for dragging down colour.

Rippled reflections

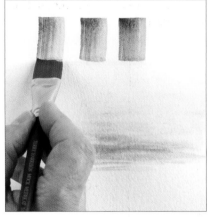

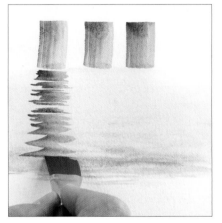

1. Paint the water with cobalt blue, adding ripples at the front and leaving some paper white. Allow to dry.

2. Double load the brush with burnt umber on one side and yellow ochre on the other and paint three posts, using the width of the brush.

3. Double load the brush in the same way and paint a rippled reflection, lifting the brush after each horizontal stroke at the top, then zigzagging down.

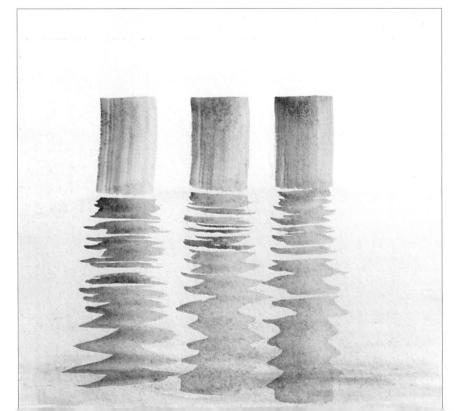

The finished rippled reflections.

Cliffs and rocks

1. Paint the clifftops with dilute Hooker's green and olive green.

2. Mix cobalt blue with a little raw sienna and drag this colour down to paint the furthest cliff.

3. Paint the nearer cliff in the same way with a mix of ultramarine and burnt umber.

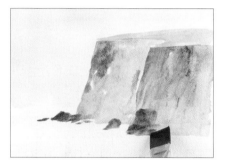

4. Use the same mix to paint the rocks at the base of the cliffs. Allow to dry.

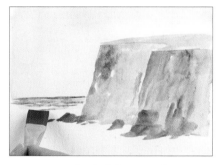

5. Mix cobalt blue and Hooker's green and use the flat edge of the brush and a side-to-side motion to create rippled water in the distance.

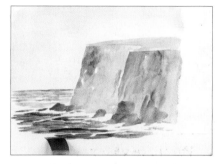

6. Make a stronger, greener mix of the same colours and paint the foreground water, creating larger ripples and leaving white for foam.

The finished scene.

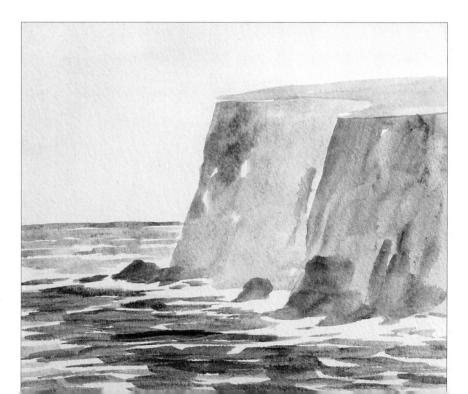

Half-rigger

This brush has long hairs that come to a very narrow point, so it is great for very fine detail such as branches, twigs and grasses in landscapes. If you load the brush fully with paint, you will be able to paint long, continuous lines, which is why it was ideal for painting the rigging of boats. It can also be used to paint window frames and other small building details, and lettering, such as in shop signs.

Window frames

Here I have painted the many buildings in this busy scene, and am going back over the dark shapes left for windows with the half-rigger and white paint, to create the window frames.

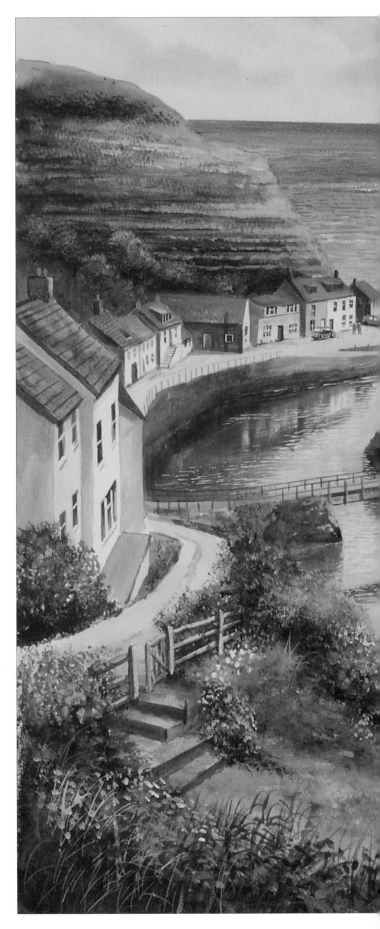

Staithes

This view of Staithes, which is on the Yorkshire coast, can only be reached by a very steep climb, after which you are rewarded by a magnificent roof-top view. The half-rigger is the perfect brush for this harbour view, not just for the boats, but the detailed window frames, the roof tiles and the railings on the bridge. The cresting waves out in the bay and the ripples on the water in the harbour are all carefully painted using the half-rigger. To finish, I used the same brush to paint fine grasses in the foreground.

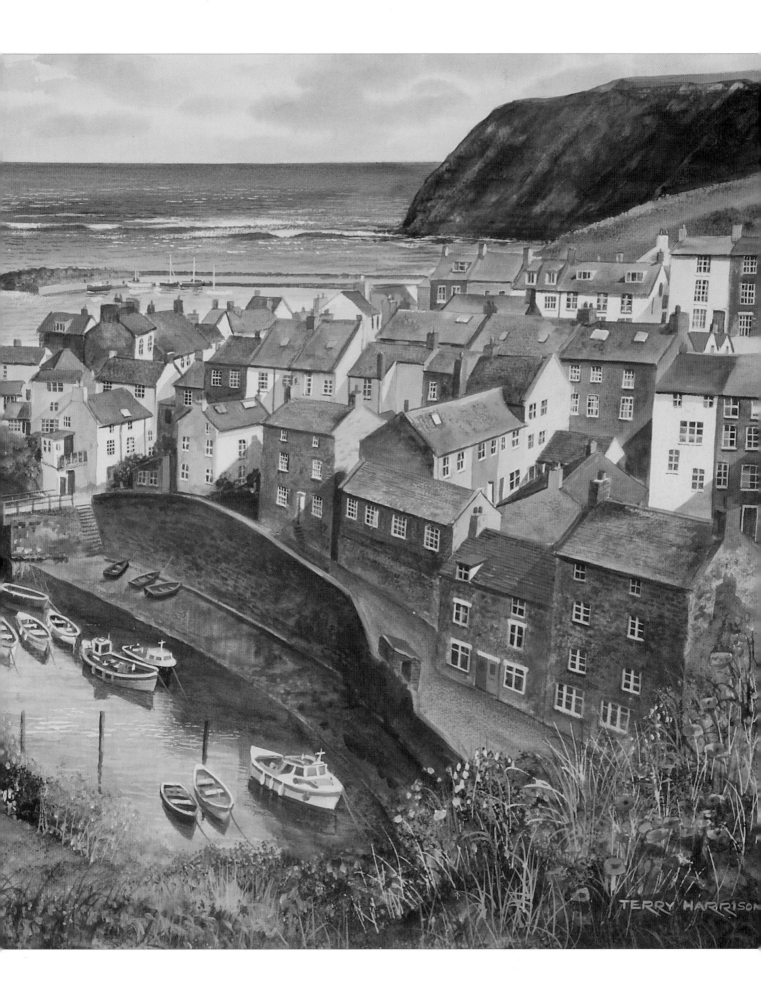

Detail brushes

Most artists will reach for a round brush for much of their painting work, and some say that these are all you need. Obviously, I don't agree with that, but you certainly need round brushes that keep their points. These are my round brushes, designed for varying levels of detail. Consider the area you need to cover when choosing which brush to use. Don't fiddle with a small brush if you need to paint a large area – just use a large brush, and change to a smaller one when you need more detail.

Small figures – small detail brush

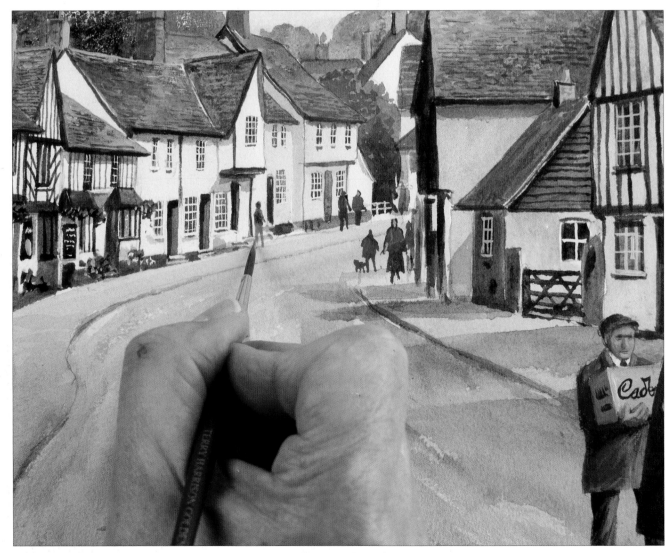

Here I am using the small detail brush to add distant figures. I used burnt umber for the head, a mix of burnt umber and ultramarine for the jacket, then cobalt blue and white for the trousers.

A half-timbered cottage – medium detail brush

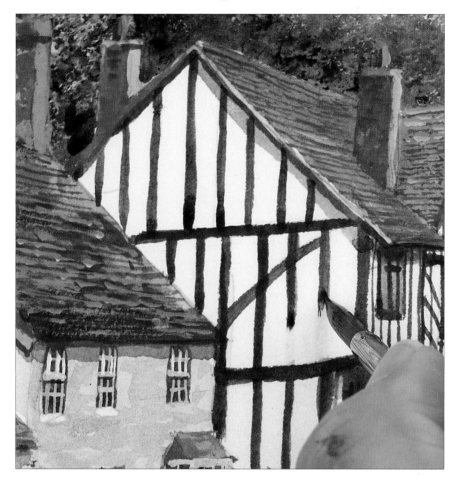

In the same painting, I used the medium detail brush to paint the dark timbers on this cottage with a mix of burnt umber and ultramarine.

The finished cottage.

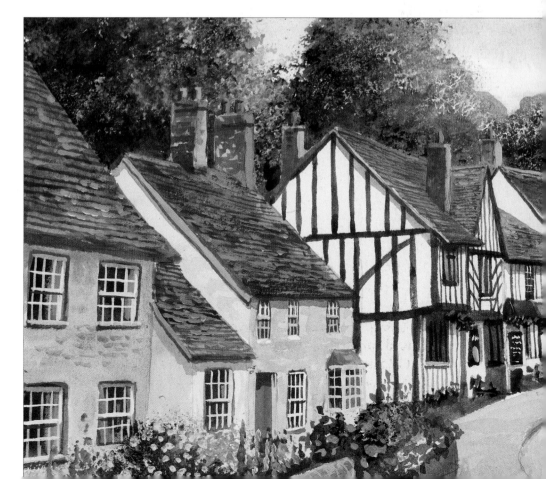

Tracks – large detail brush

1. Paint the foreground with yellow ochre, raw sienna and white.

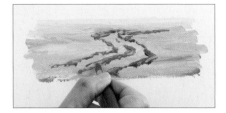

2. While this is wet, paint the edges of the tracks with burnt umber. Allow to dry.

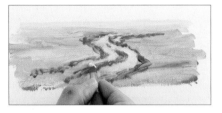

3. Use the tip of the brush to paint the water in the furthest part of the tracks with a mix of white and cobalt blue, and bring this forwards where the track widens.

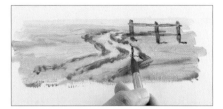

4. Paint the fence and its reflection with burnt umber and ultramarine.

The finished scene.

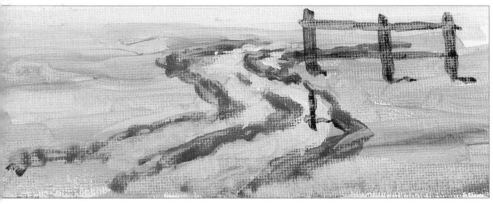

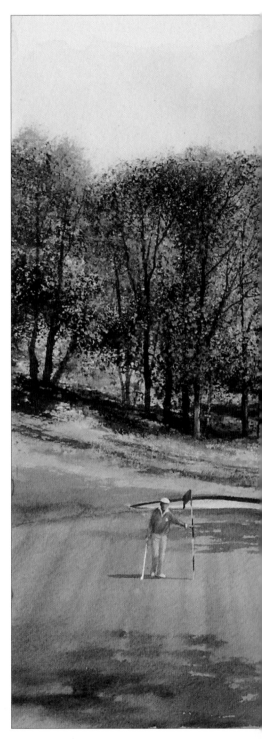

High Tee
To most people this is a landscape painting with some people in it; to others this is golf and should not be taken lightly. To achieve this degree of detail requires a brush with a very fine point such as the small detail brush, and a degree of patience.

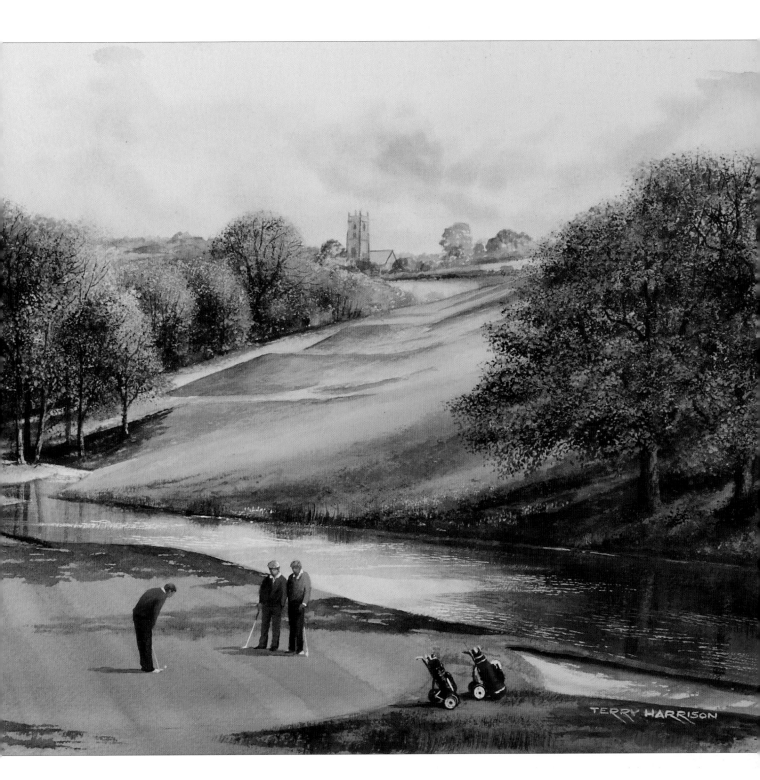

Overleaf
High Tide, Clovelly

This painting of picturesque Clovelly incorporates many different techniques that appear in this book. I painted the trees and added texture to the buildings by stippling with the foliage brush. I left the window frames until last – I find it very satisfying to paint every window frame carefully using the half-rigger, as this is when I gradually see the painting come together in its finished form.

TECHNIQUES

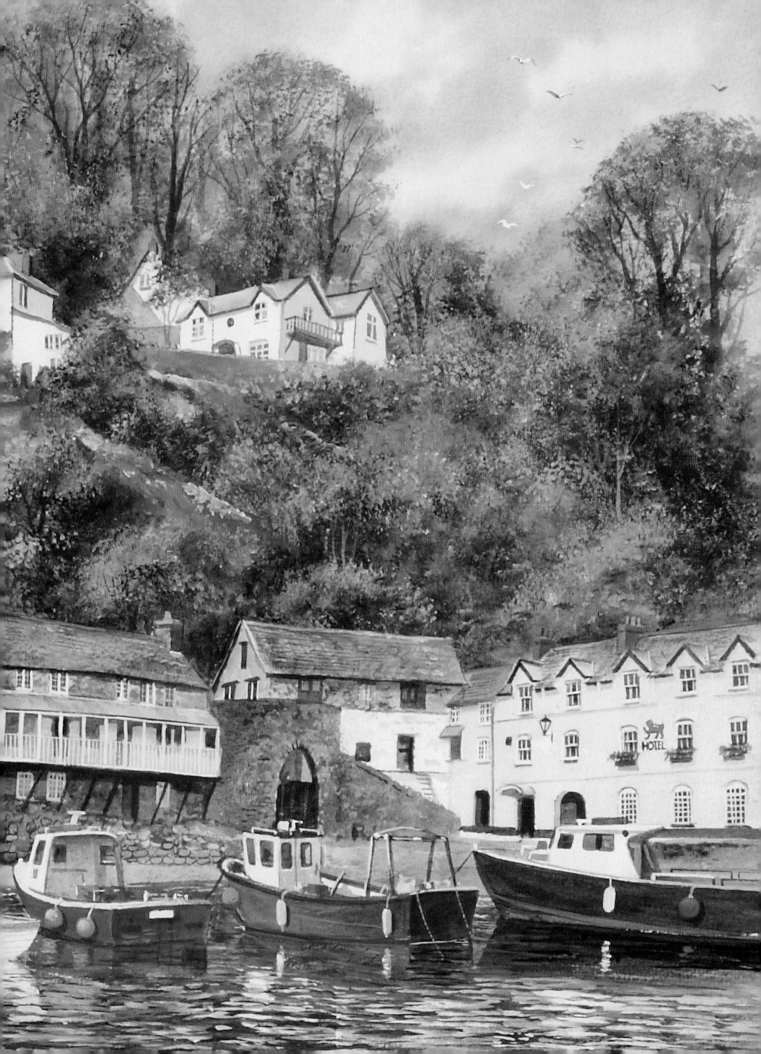

Painting a tree close-up

The prospect of painting a summer tree with foliage close-up may at first seem daunting, but by using the golden leaf brush and a stippling technique, you can create an open texture which looks as though you have painted every individual leaf. Make sure the golden leaf brush is not overloaded with paint or too wet, or the texture will flood together and create a flat wash. Before you apply the paint, test the brush on scrap paper, and if it is too wet, tap it on some kitchen paper to remove the excess paint.

1. Take the golden leaf brush and paint the lightest part of the background with cobalt blue and white, then stipple on a mix of white and cadmium yellow.

2. Pick up a mix of cobalt blue and pale olive green and stipple this on to create foliage. Allow to dry.

3. Continue painting around the edges of the lighter area with a darker mix of cobalt blue and pale olive green. Then stipple ivy over the tree trunk with Hooker's green.

4. Extend the texture by stippling over the whole foliage area with a mix of olive green and Hooker's green. Flick up grasses on the ground with the same mix.

5. Stipple yellow ochre and pale olive green further forwards.

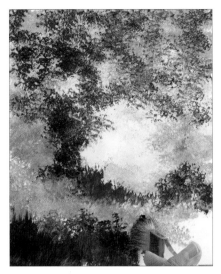

6. Add a little of this mix to Hooker's green and paint this strong, dark green in the foreground. Allow to dry.

7. Paint the tree trunk and branches with the large detail brush and a mix of Hooker's green and burnt umber.

8. Stipple on highlights in the foliage with the golden leaf brush and white with pale olive green.

9. Stipple flowers and grasses in the foreground with a mix of cadmium yellow and white.

The finished tree.

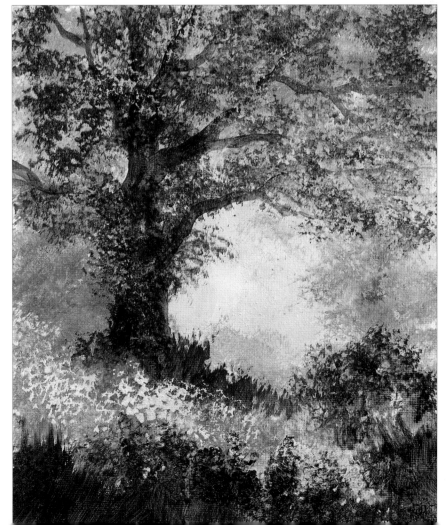

Country Lane

Having trees in the foreground together with some shadows can help frame a focal point. In this painting I have framed the distant view in this way: the branches of the foreground trees overhang the track to form the top of the frame and the tree trunks and bush form the sides, then the shadow runs along the bottom of the painting to complete the frame. The white flower heads at the side of the road are carefully positioned over the dark shadows; this breaks up the shadows and makes the flowers stand out.

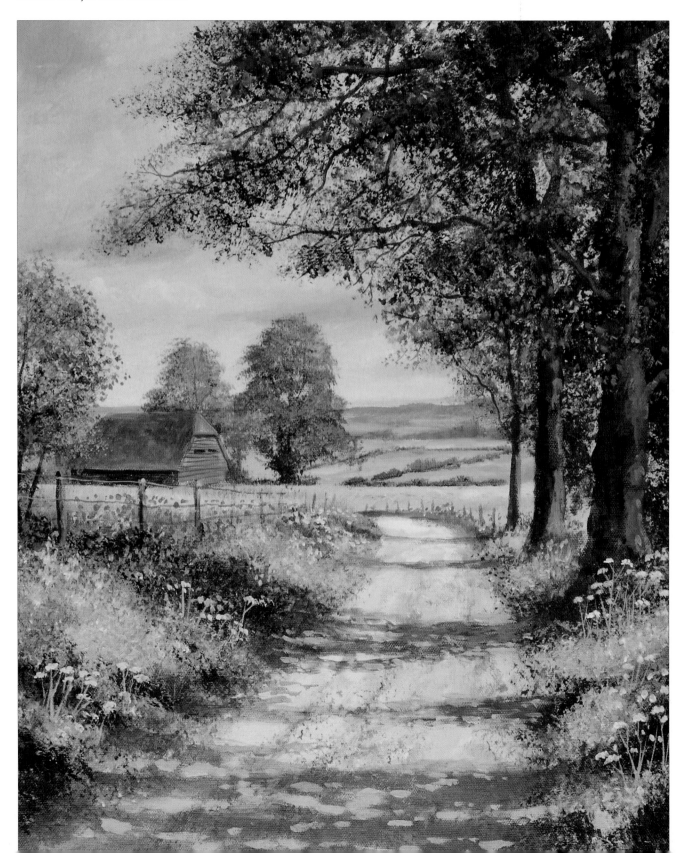

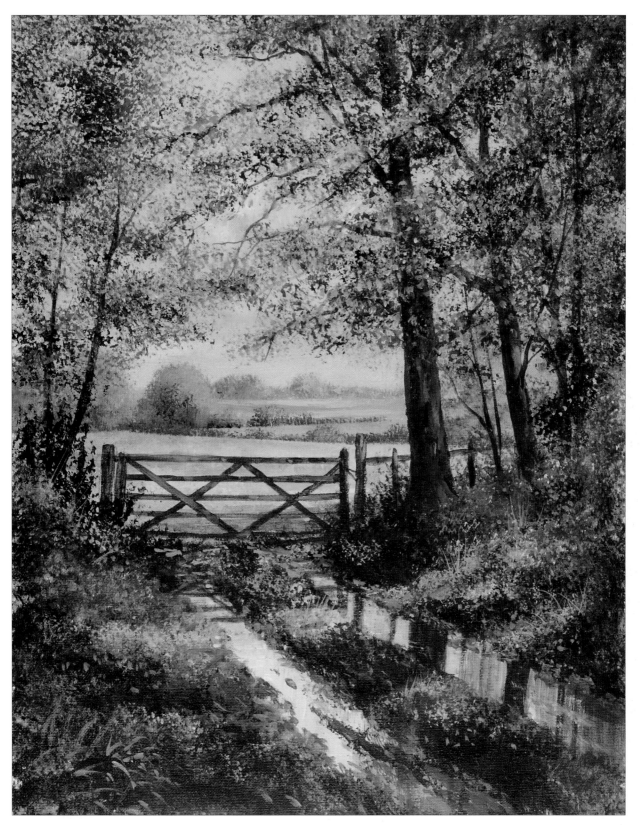

Wet Underfoot

Almost half of this painting is covered with foliage created using the golden leaf brush. Care was taken not to overdo this and fill in the texture, so you can still see some sky through the leaves. The dark tones in the foreground help to emphasise the sunlight on the cart track and the puddles.

Painting reflections

Still reflection with the wizard

1. Paint the scene above the waterline.

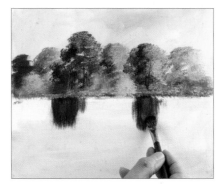

2. Start with the darkest reflections. Pick up Hooker's green on the wizard and drag the colour down.

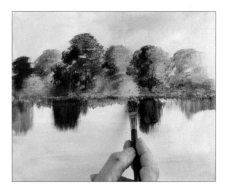

3. Next pick up olive green and drag this down as shown.

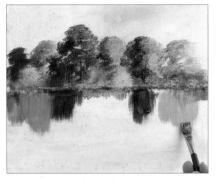

4. Drag down a mix of cobalt blue, white and Hooker's green to create the cooler reflections.

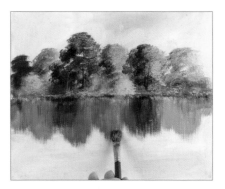

5. Paint more reflections with Hooker's green and olive green.

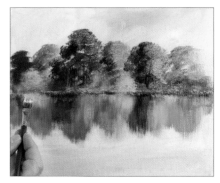

6. Add lighter touches with pale olive green and white.

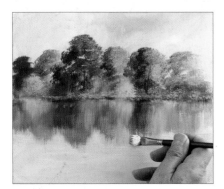

7. Soften and blend the edges of the reflections with horizontal strokes of white and cobalt blue.

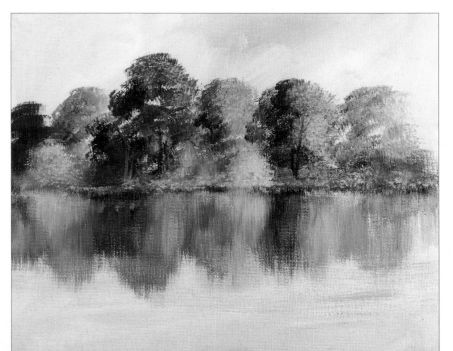

Rippled reflection with the 19mm (¾in) flat

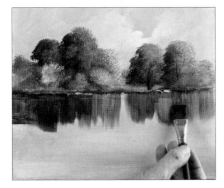

1. Paint the scene above the waterline. Use the 19mm (¾in) flat brush and Hooker's green and olive green to drag down reflections.

2. Use the flat end of the brush with a dark mix to paint short, horizontal strokes across the reflection for ripples. Allow to dry.

3. Paint lighter ripples beneath lighter areas with pale olive green and white.

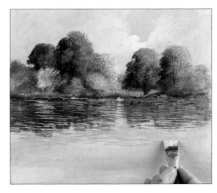

4. Paint yellow ochre ripples where appropriate.

5. Mix white and cobalt blue and paint light ripples over the edges of the reflection.

6. Paint ripples in a darker blue mix further forwards.

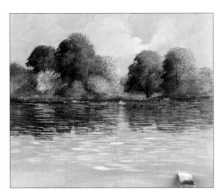

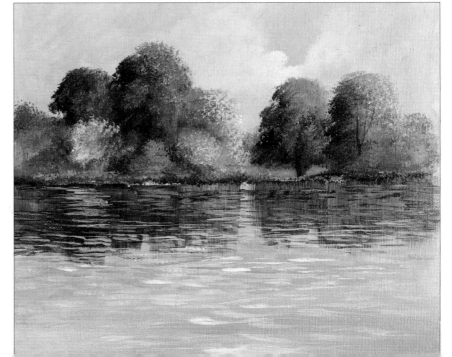

7. Paint larger white ripples in the foreground.

Creating distance

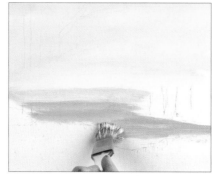

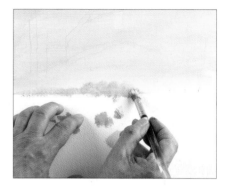

1. Draw the scene, then use the golden leaf brush to paint the sky with cobalt blue and white, making it stronger at the top. Add a touch of raw sienna to the mix and paint the distant field.

2. Add burnt sienna at the bottom of the field for warmth, then add pale olive green and paint the misty area coming forwards. Allow to dry.

3. Use a paper mask and the stippler px brush to stipple the distant row of trees with cobalt blue, white and raw sienna.

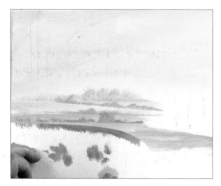

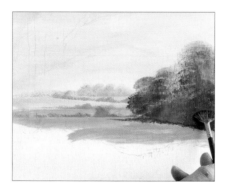

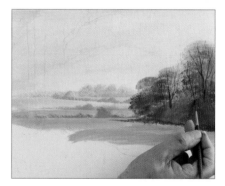

4. Add more raw sienna to warm the mix and hold the paper mask at an angle to stipple another hedgerow. Continue changing the angle of the paper mask and adding stronger hedgerows coming forwards.

5. Use the fan stippler to paint a bank of trees on the right with raw sienna, cobalt blue and white. Paint darker foliage with burnt umber, cobalt blue and white, making it darkest at the base.

6. Paint the trunks and fine branches with the half-rigger and the same dark mix.

7. Stipple undergrowth further forwards with the stippler px and burnt umber and ultramarine. Use the golden leaf with a dark mix of burnt umber and ultramarine to stipple the foreground and flick up grasses.

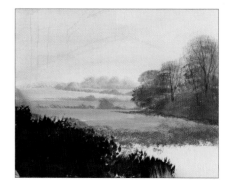

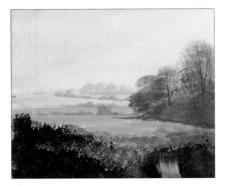

8. While this is wet, stipple on a mix of white and raw sienna to create a central light area like a path leading the eye into the composition.

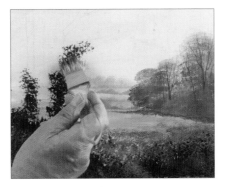

9. Make a dark mix of burnt umber and Hooker's green and stipple on the ivy covering the trunks. Allow to dry.

10. Paint the trunks and branches with the large detail brush and burnt umber with a little Hooker's green. The lower branch should overlap the distant trees.

11. Mix a blue-grey from ultramarine, burnt umber and white and use the golden leaf brush to suggest winter leaves.

12. Use the half-rigger to paint fine branches and twigs with the same mix.

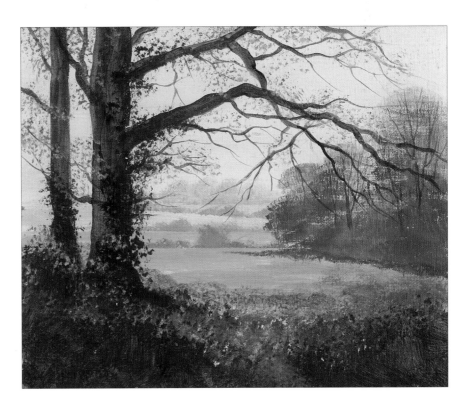

The finished scene.

Painting snow

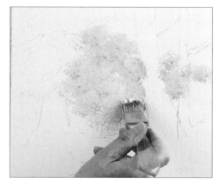

1. Use the golden leaf brush to stipple on patches of cobalt blue and white with a tiny touch of alizarin crimson.

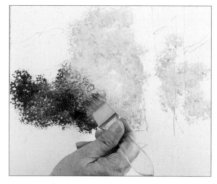

2. Stipple on patches of winter foliage with burnt umber and a touch of dioxazine purple.

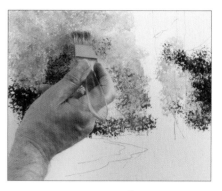

3. Continue stippling winter foliage with cobalt blue and a touch of burnt sienna.

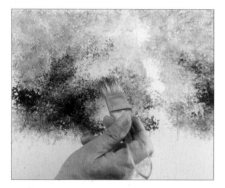

4. Stipple a little greener foliage with Hooker's green.

5. Paint a little greenery on the ground with the same colour, then paint the snow with cobalt blue and white. Allow to dry.

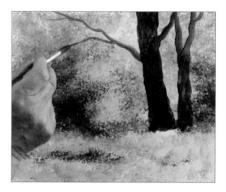

6. Use the large detail brush to paint dark trunks and branches with burnt umber and Hooker's green.

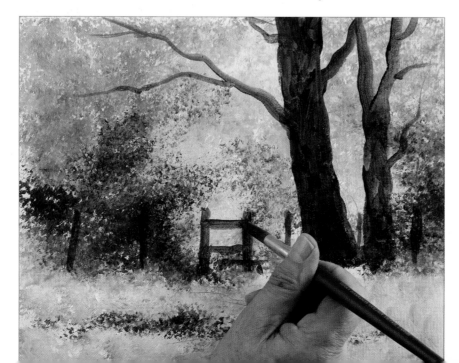

7. Use the same brush and mix to paint a stile and fence.

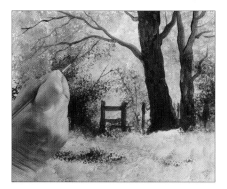

8. Change to the half-rigger to paint fine branches and twigs.

9. Mix pale olive green and yellow ochre and use the large detail brush to paint marks along the lighter sides of the trees, suggesting the texture of the bark.

10. Use the medium detail brush and white to paint snow on the fence posts and stile. Change to the golden leaf brush and stipple snow in the trees and on the ground.

The finished snow scene.

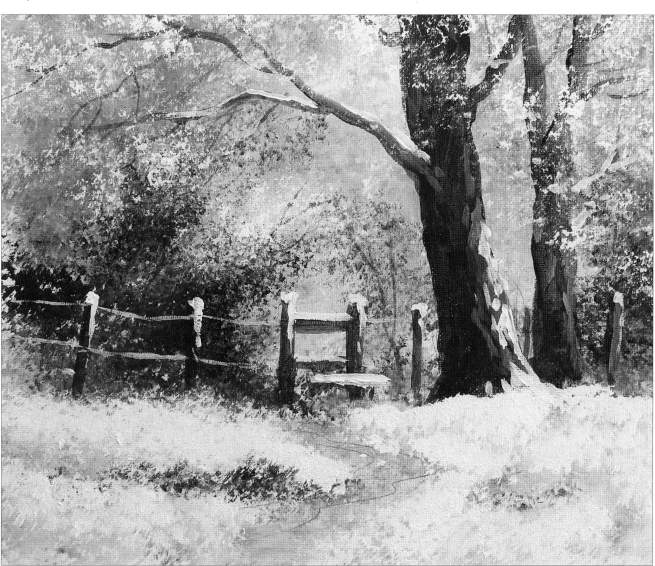

Turning a summer scene into a winter scene

I rely strongly on using photographs for my paintings. I try not to copy them exactly, but rather use them as reference and for gathering details. If I were merely to copy a photograph, I might just as well frame the photograph itself.

From this photograph, I have used the layout and composition to create two paintings. The first is a summer scene similar to the photograph, although I have added some poppies for colour and also some shadows in the foreground to help frame the mill.

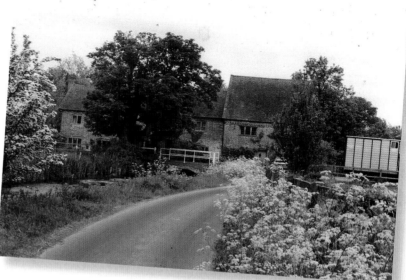

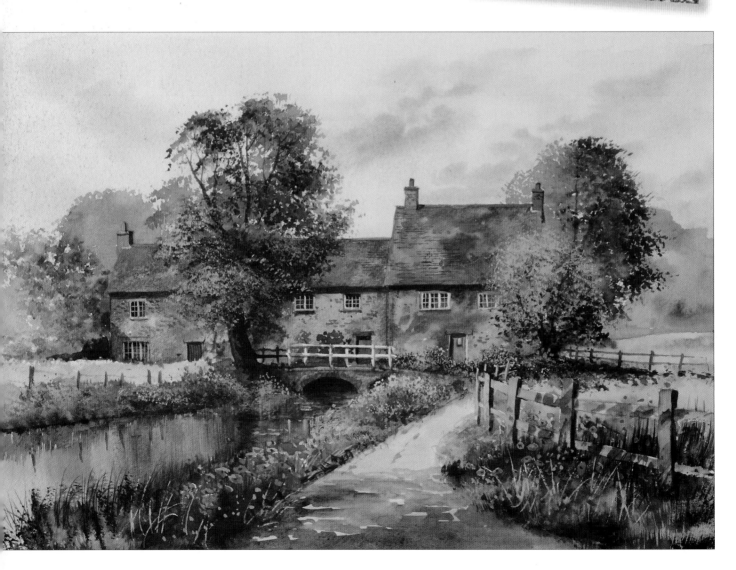

For the winter scene I have retained the same composition and viewpoint – the building and bridge are painted exactly the same as in the first painting with the exception of the roof, which is now covered in snow.

The green shades of summer are simply replaced with a coating of snow as described on pages 68 and 69.

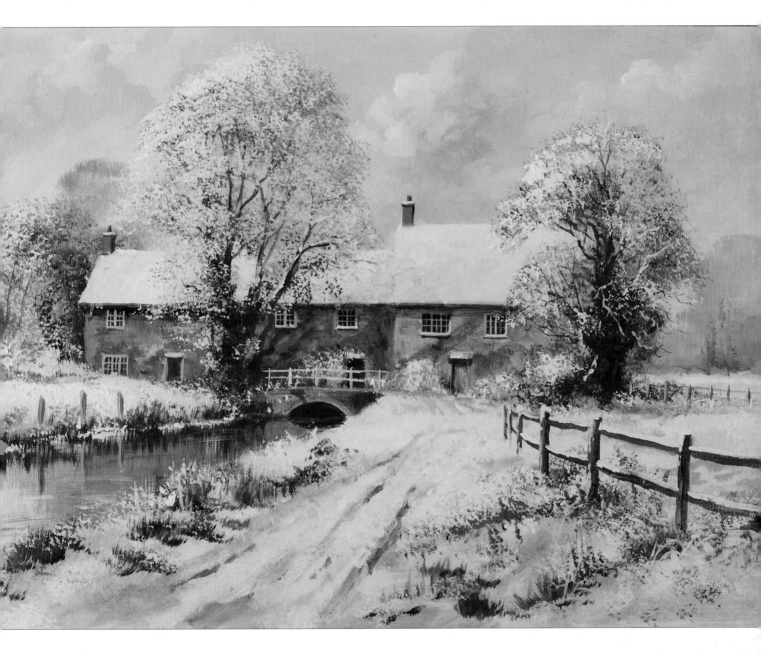

Adding life

How do you know when a painting is finished? We are always told not to overwork them. When you feel a painting is complete, leave the room, then later return with fresh eyes and look at it again. You may feel that it needs a little finishing touch – perhaps it lacks a focal point or has a blank space that needs something of interest added. I suggest adding something living, such as a few chickens in a farmyard, ducks on a pond, sheep in a field or people in the street. The key to success is not to make them too large, or they will dominate the scene and it will become a painting about chickens or ducks. Adding living things to a painting in this way can really bring it to life.

Chickens

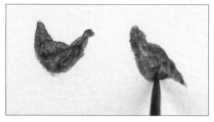

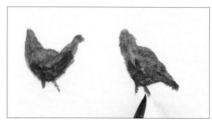

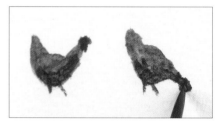

1. Use the small detail brush to paint the head and body shapes with burnt sienna. The second chicken is pecking the ground.

2. Mix ultramarine and burnt sienna and shade the undersides of the chickens, then paint in simple legs.

3. Add the combs with cadmium red.

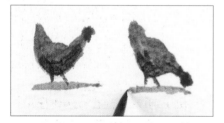

4. Paint in shade under the chickens with ultramarine and burnt sienna. This helps to give them a context.

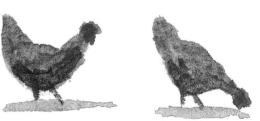

The finished chickens.

Duck

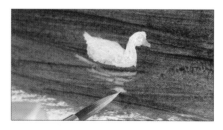

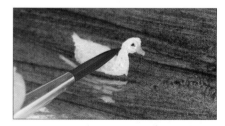

1. Paint the water first, then use the small detail brush and white paint to paint the duck shape. Add cadmium yellow and paint the beak.

2. Paint white ripples beneath the duck.

3. Paint the eye with burnt sienna and ultramarine.

The finished duck.

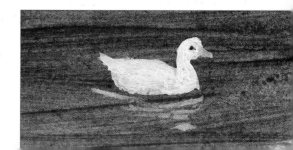

Cockerel

1. Paint the body and head shape with burnt sienna, then add ultramarine and paint the shaded underside and the legs.

2. Mix ultramarine and Hooker's green and paint the tail feathers.

3. Paint the comb with cadmium red, then add cadmium yellow and white to paint the chest.

4. Paint a shadow with burnt sienna and ultramarine.

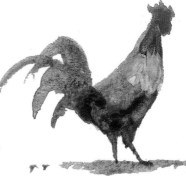

The finished cockerel.

Goose

1. Paint the background first, allow it to dry, then paint the head and body shape in white with the small detail brush.

2. Add cobalt blue and paint the grey parts under the body.

3. Mix ultramarine and burnt umber, and paint the shadowed underside and the legs.

4. Mix cadmium red and cadmium yellow and paint the beak and legs.

5. Use ultramarine and burnt umber to dot in the eye and to paint a shadow.

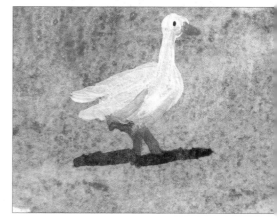

The finished goose.

Pheasant

1. Use the small detail brush to paint the head and neck in Hooker's green and the body in burnt sienna.

2. Mix cadmium red and ultramarine to paint the dark markings and the legs.

3. Paint the chest with cadmium red and cadmium yellow, then dot in the eye with cadmium red.

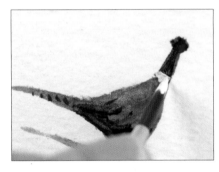

4. Paint the shadow on the ground with burnt sienna and ultramarine, then add the neck ring with white.

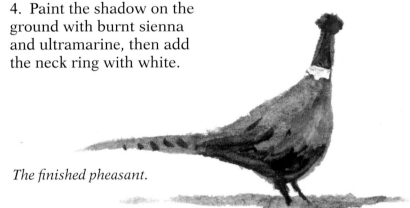

The finished pheasant.

Cow

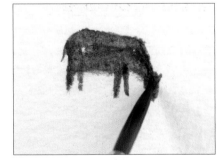 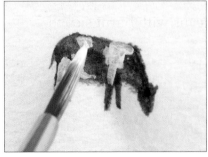

1. Use the small detail bruth to paint the cow with ultramarine and burnt umber. Allow to dry.

2. Paint on white patches. Add a shadow with burnt umber and ultramarine.

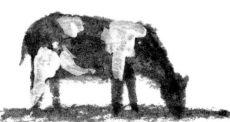

The finished cow.

Sheep

1. Paint shapes with raw sienna and white on the small detail brush.

2. Paint the dark and shaded parts with ultramarine and burnt umber.

The finished sheep.

Figures

1. Paint heads with the small detail brush and burnt umber and ultramarine.

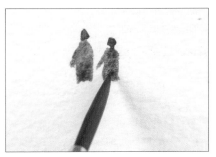

2. Paint one torso with cerulean blue and the other with burnt sienna. Suggest arms with burnt sienna.

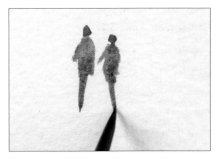

3. Give each figure one leg first, with a mix of ultramarine and burnt

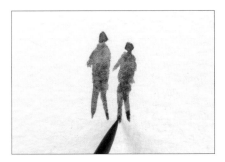

4. Paint in a second leg for each figure.

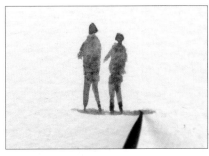

5. Paint a shadow beneath the figures with ultramarine and burnt umber.

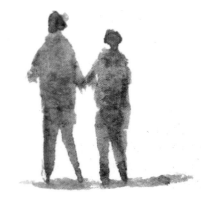

The finished figures.

Using texture pastes

Texture pastes are perfect for use with acrylics, and can be used to create a variety of textures from rocks to grass to plastered buildings.

Beach scene

1. Use a painting knife to apply texture paste to the cliff face, distant headland, rock and surf line.

2. Use the stippler px to put texture paste on the beach and the sea spray. Allow to dry.

3. Use the foliage brush with cobalt blue and white to paint the sky. Add more cobalt blue to paint clouds.

4. Paint the sea with horizontal strokes of the foliage brush and a mix of ultramarine and Hooker's green, adding more green as you come forwards.

5. Use the 19mm (¾in) flat brush to paint ripples with a darker mix of ultramarine and Hooker's green.

6. Mix white and cobalt blue to paint rolling foam using the foliage brush.

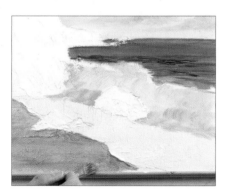

7. Mix yellow ochre with a little cobalt blue and paint the beach.

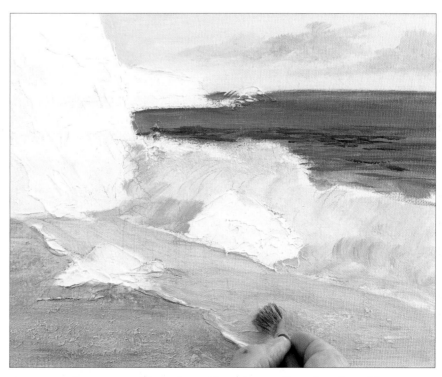

8. Paint the area of beach under the surf with a less blue mix of the same colours.

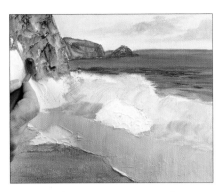

9. Paint white and cobalt blue over the surf area and drag this down to suggest reflections in water. Allow to dry.

10. Paint the distant headland and rock with ultramarine, burnt umber and a little white, with the large detail brush.

11. Make a watery wash of ultramarine and raw sienna and paint this over the texture paste on the cliff, varying the mix as you go.

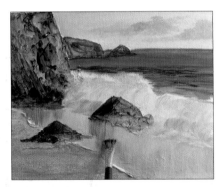

12. Paint the rocks with the same mix, then drag down reflections with the foliage brush.

13. Use the 19mm (¾in) flat brush to paint white ripples, and to drag white down the foaming waves.

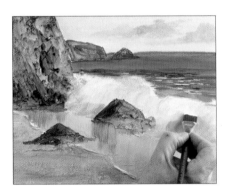

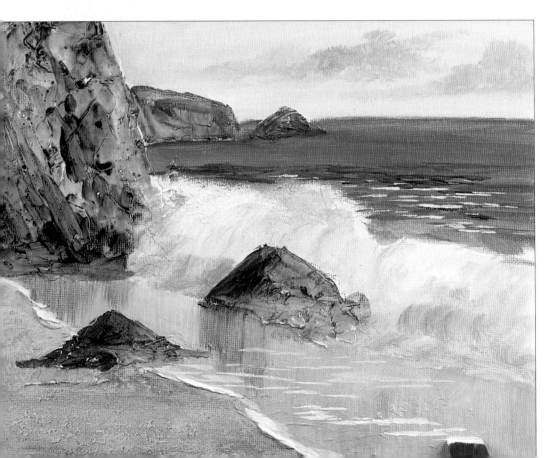

14. Paint white along the surf line, then add fine lines in the surf.

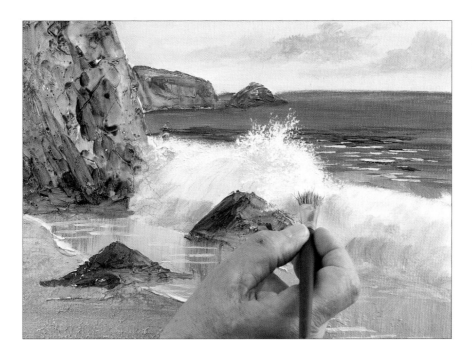

15. Paint the spray over the texture paste with the folliage brush and white.

The finished painting.

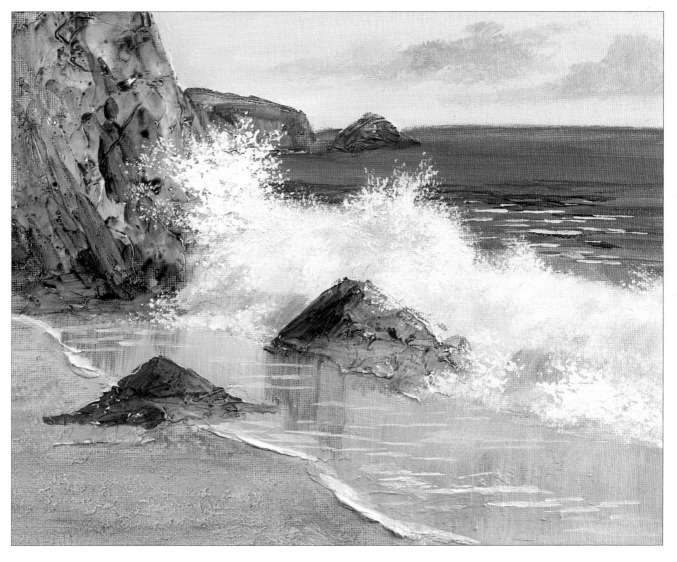

Using glaze medium

Glaze medium straight from the tube is a pale, milky white paste. It is much softer than acrylic paint. When it dries, it is transparent, and when colour is added to the medium it remains transparent and can be used to lay a thin glaze or tint over another colour. Glaze medium can also be used as a clear varnish to protect your finished painting.

Shafts of light

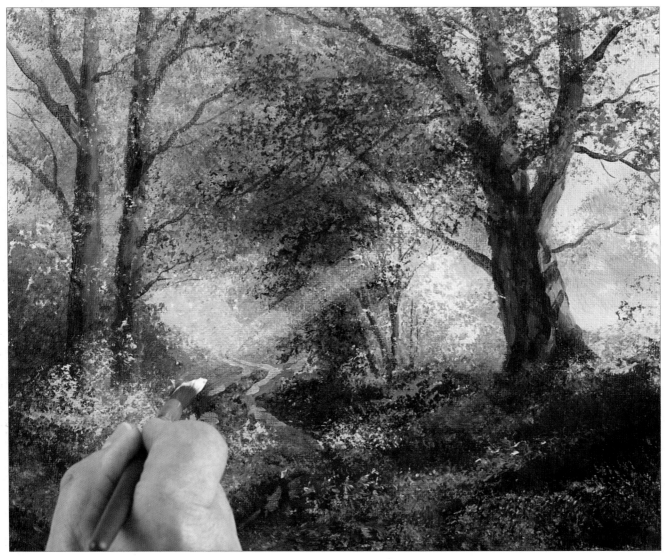

Mix glaze medium with a touch of white paint and use the large detail brush to add a shaft of light coming through the trees. Make sure you paint long, straight brush strokes and work fairly quickly to avoid the brush wobbling.

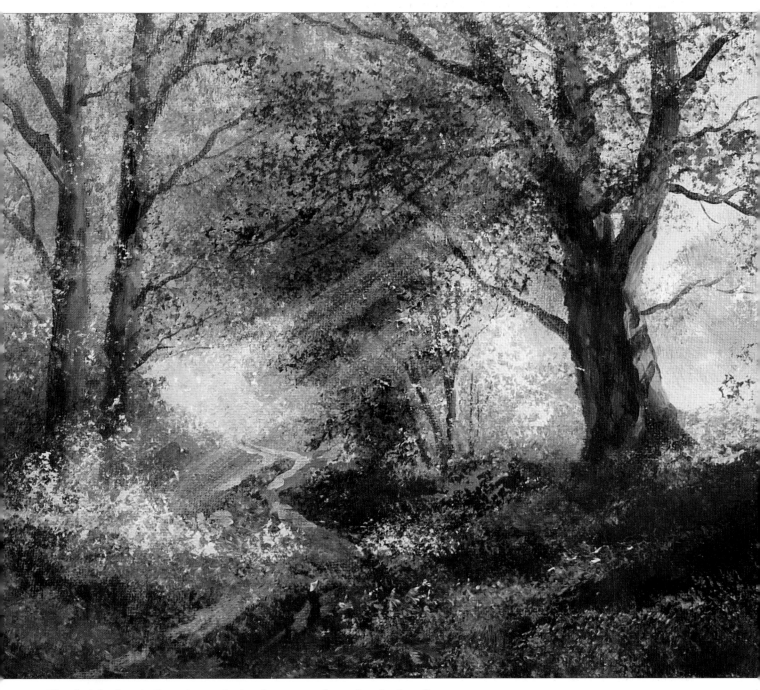

The finished painting. A top tip is always to place the shafts of sunlight over the darks; this will help them to stand out against the background.

Misty water meadow

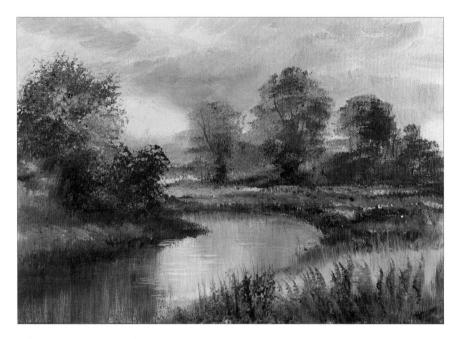

This is a painting of a water meadow with most of the painting completed. However, I wanted to capture the mist that hung over the distant fields, softening the trees and creating a tonal contrast with the brighter, stronger colours of the foreground. This kind of effect can really add mood and atmosphere to a painting.

I used the large detail brush and a mix of glaze medium and white paint to add a layer of mist lying over the water meadow and partly obscuring the distant trees.

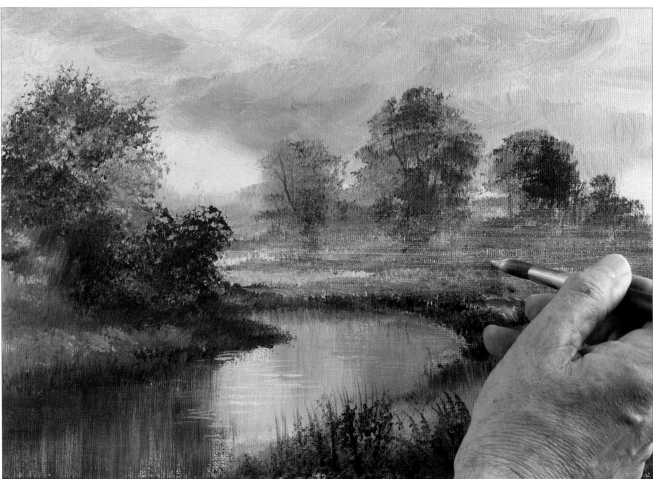

The finished painting. Care must be taken when glazing, as too much paint in the glaze will result in a solid wash. Before applying the glaze mix to the painting, always try it out first on a scrap piece of paper. If it is too opaque, add more glaze to the mix.

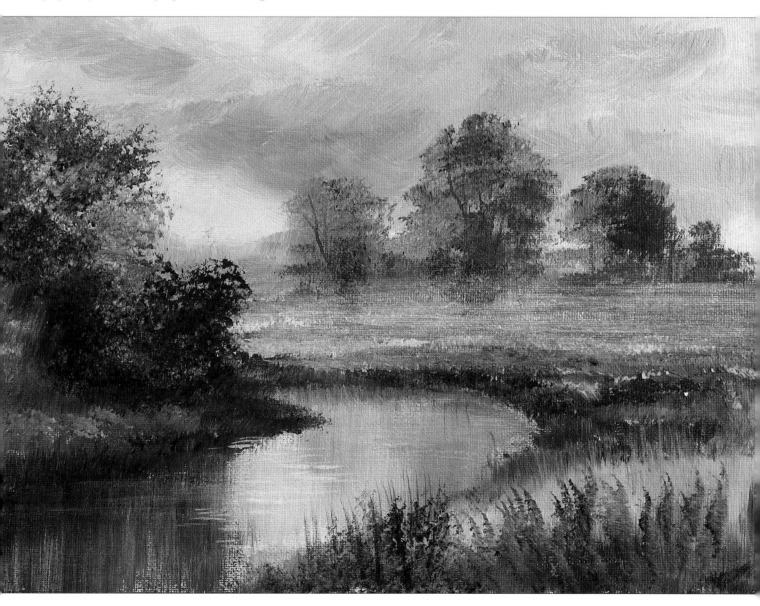

Using painting knives

Rocks

1. Mix white and raw sienna and use the painting knife to paint the beach.

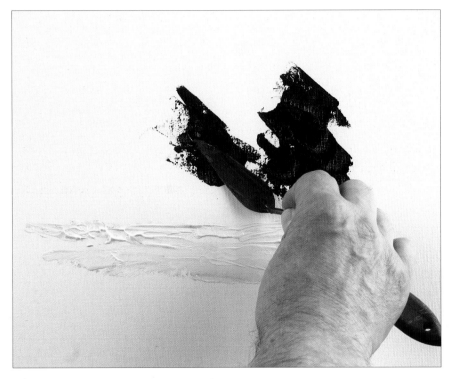

2. Make a mix of ultramarine and burnt umber that is not thoroughly mixed and put in the darker parts of the rocks.

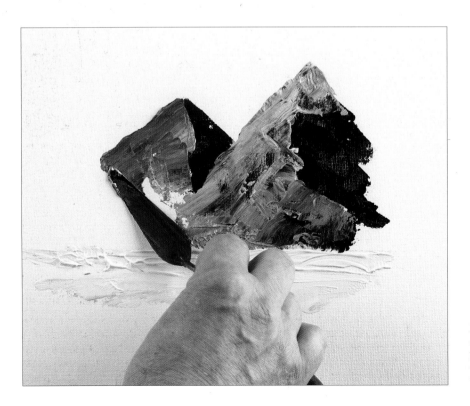

3. Still using the painting knife, apply a mix of raw sienna and white for the lighter parts of the rocks.

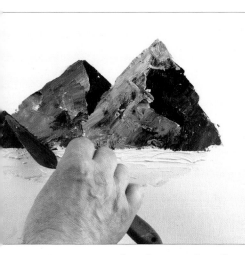

4. Paint a third triangle of rock using the dark mix.

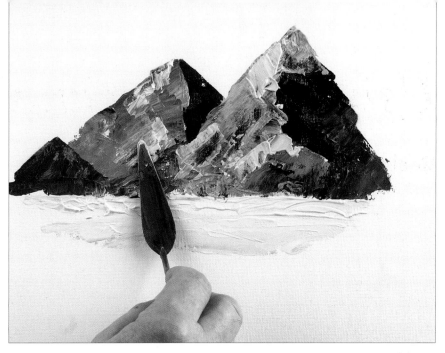

5. Add highlights with white and yellow ochre.

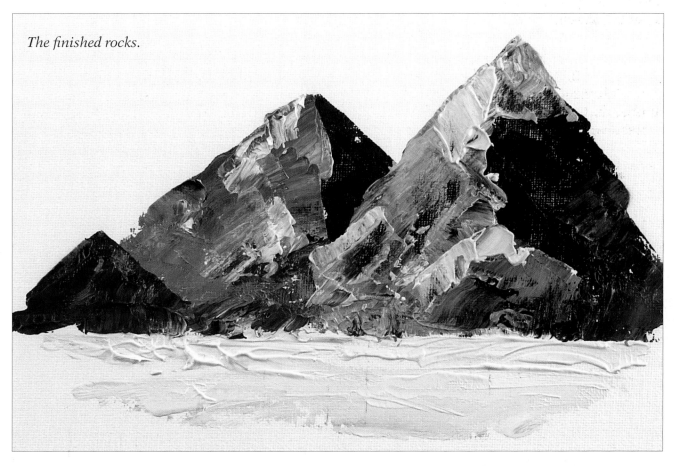

The finished rocks.

Overleaf
Brixham Harbour
This colourful and detailed painting uses many of the techniques and brushes covered in this book. The textures of the harbour wall and the trees and some of the detail on the roofs were created using the foliage brush. The half-rigger is not just for rigging – I used it for all the fine detail on the windows and also the lettering on the buildings. For the reflections of the boats I used the 19mm (¾in) flat brush.

DEMONSTRATIONS

Summer Landscape

This summer scene is fairly simple; it is divided into just three layers and mostly painted using the golden leaf brush. Begin with the sky and distant trees, then the middle distant trees in the lane, and finish with the large tree in the foreground, reflected into the water. The shadows across the lane are quite an important part of the composition as they help link one side of the painting with the other, and break up the eyes' journey down the lane and into the painting.

You will need

Canvas board, 50.8 x 40.6cm (20 x 16in)

2B pencil

Golden leaf, stippler px, foliage, large detail, half-rigger, medium detail, wizard, small detail

Paints – see page 10

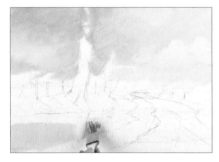

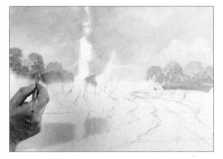

1. Draw the scene with a 2B pencil.

2. Paint the sky with the golden leaf brush and cobalt blue and white. Add a little yellow ochre to paint clouds at the bottom right and then the water.

3. Use the stippler px to stipple on distant trees with cobalt blue, white and a touch of olive green.

4. Paint the foliage in the centre with the golden leaf brush and white, cobalt blue and Hooker's green.

5. Stipple the trees in the middle distance with Hooker's green, pale olive green, white and yellow ochre. Stipple darker foliage with Hooker's green and olive green. Leave a 'hole' in the foliage for the road.

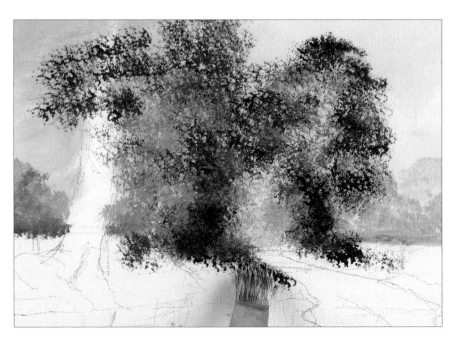

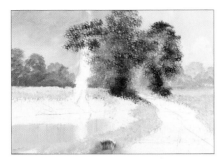 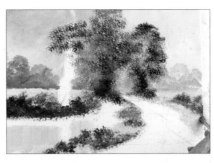 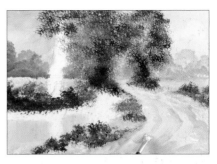

6. Paint the distant field on the right with white and pale olive green, and add yellow ochre for the left-hand field and the verges.

7. Use a mix of olive green and Hooker's green to paint the banks of the stream and the hedge on the right.

8. Paint the lane with white and yellow ochre and add more raw sienna as you come forwards. Change to the foliage brush to paint the ruts.

 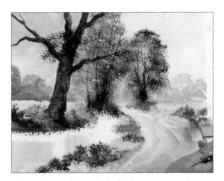

9. Paint the tree trunk with the large detail brush and a mix of Hooker's green and burnt umber.

10. Change to the half-rigger to paint the middle distance tree trunks.

11. Add highlights to the middle distance trees and the hedges with the golden leaf and a mix of white and pale olive green.

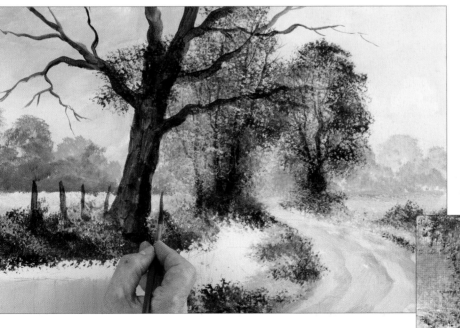

12. Use the medium detail brush and Hooker's green and burnt umber to paint more branches and fence posts. Add a gate in the same way.

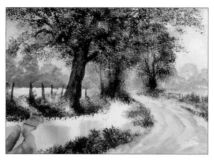

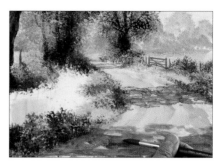

13. Stipple foliage all around the main tree with Hooker's and olive green on the golden leaf, then add highlights with pale olive green and white.

14. Stipple highlights in the undergrowth beside the stream with white and cadmium yellow.

15. Use the medium detail brush to paint distant shadows across the road with white, cobalt blue, permanent rose and burnt sienna. Use the large detail brush to paint dappled shadow further forwards.

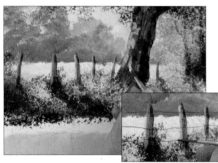

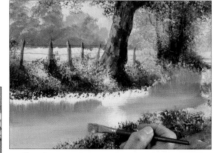

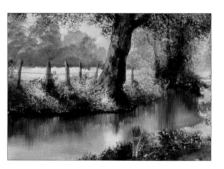

16. Mix pale olive green, yellow ochre and white and use the medium detail brush to highlight the fence posts and tree trunk. Paint the fence wire with burnt umber and the half-rigger.

17. Use the wizard to drag down reflections in the water with white, cobalt blue and olive green, then blend these in with horizontal strokes of cobalt blue and white.

18. Drag down Hooker's green and olive green to reflect the dark at the water's edge, then do the same with a lighter mix of pale olive green and white.

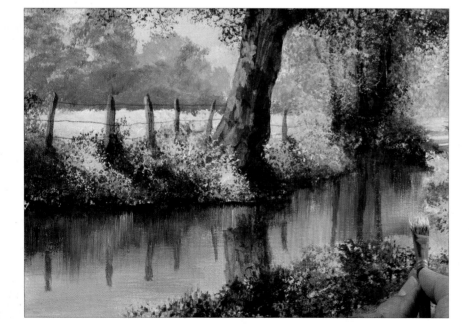

19. Paint the reflections of the tree trunk and fence posts with burnt umber and Hooker's green on the medium detail brush. Use the wizard to paint reflections of the sky and distance with cobalt blue and white.

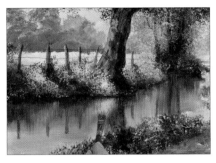

20. Add light reflections with pale olive green and white. Allow to dry.

21. Mix permanent rose and white and use the small detail brush to paint flowers. Paint more flowers with pure permanent rose.

The finished painting.

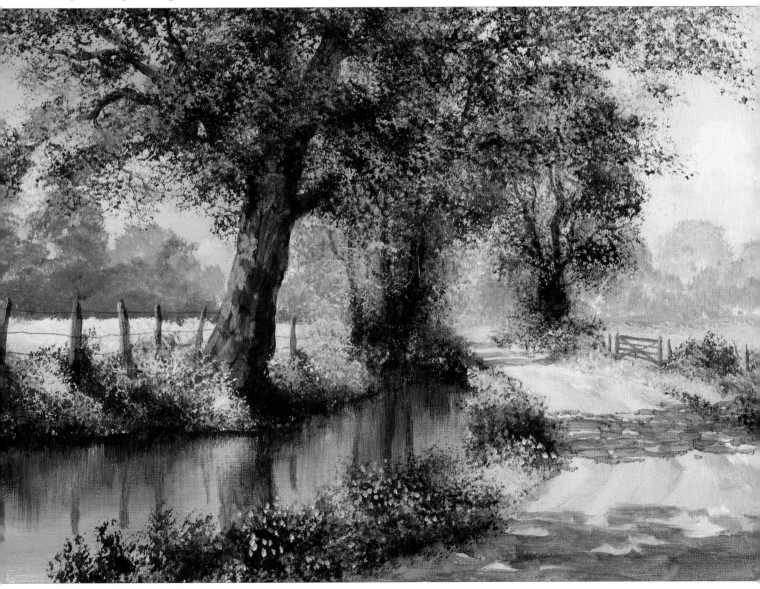

Riverbank Shade

Nearly all of this painting was created by stippling using the golden leaf brush. The sunlit riverbank with its bright, light colours contrasts strongly with the really dark shade of the trees in the foreground. Painting light is all about contrasts, and keeping the darks really dark will make your light look a lot lighter, so don't be afraid of the dark!

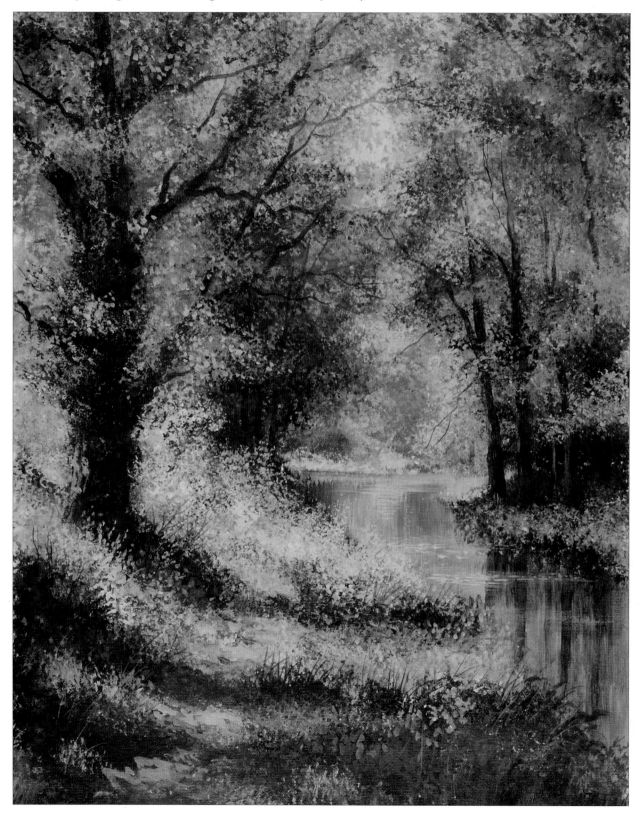

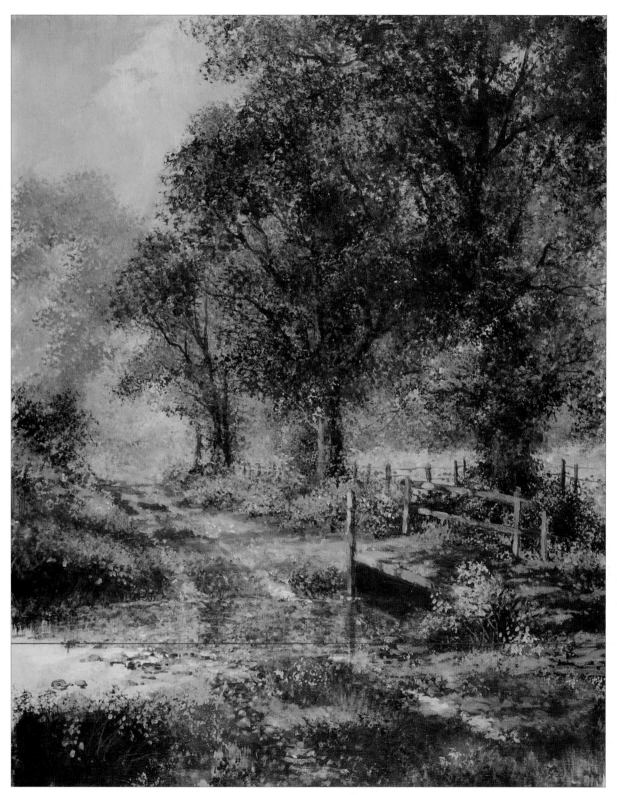

The Shallow Ford

The distant trees down the lane were painted using a mix of cobalt blue and pale olive green and lightened by adding some white. The blue tones suggest depth and distance and the viewer is drawn into the painting, over the bridge towards the light. The trees were painted using the golden leaf brush and a stippling and dabbing technique, starting with the trees in the distance, then the other trees were layered one on top of the other moving towards the foreground.

Winter Scene

A large part of this winter scene was painted using the golden leaf brush, not just for blocking in solid colour but also for the creation of textures in the trees, fields and foreground. The paper mask technique is used to good effect to create the distant hedgerows and fields. The reflections play a big part in the composition, and the puddles in the lane are carefully placed so that the trees and fence posts are reflected in the water.

You will need

Canvas board, 50.8 x 40.6cm (20 x 16in)

2B pencil

Golden leaf, foliage, fan stippler, half-rigger, medium detail, large detail, wizard

Paints – see page 10

Paper for mask

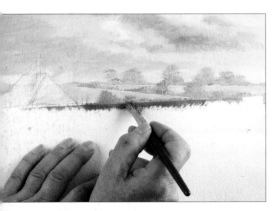

1. Draw the scene with a 2B pencil.

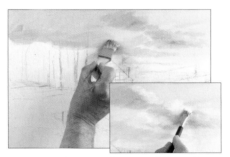
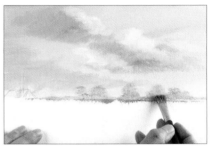

2. Use the golden leaf brush to paint the sky with cobalt blue and white, then paint clouds with ultramarine and burnt umber. Highlight the clouds with the foliage brush and white with a touch of yellow ochre.

3. Place a paper mask over the horizon and stipple on distant trees with ultramarine, alizarin crimson and white.

4. Paint the distant fields with white, yellow ochre and a touch of cobalt blue, then hold a paper mask at an angle and stipple on hedgerows with a bluer, dark mix of the same colours.

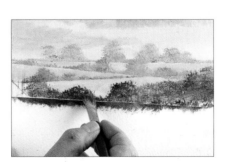

5. Stipple over the paper mask further forwards with a mix of burnt sienna and ultramarine.

6. Stipple the field in front of this with raw sienna and white, then change to the golden leaf and stipple winter foliage on the left with ultramarine and burnt sienna.

7. Add more ultramarine and white to the foliage mix and use the paper mask to help you stipple round the building, then continue stippling on the right.

8. Stipple the middle ground with white and yellow ochre, then stipple and flick up grasses in the foreground with burnt umber.

9. Mix white, yellow ochre and a touch of pale olive green and stipple and flick up grasses at the bottom of the painting.

10. Hold the fan stippler vertically to stipple ivy up the right-hand trees with Hooker's and olive green.

11. Hint at tree trunks on the left with the same method, using burnt umber.

12. Add a hedgerow across the middle ground with the same brush and mix.

13. Paint trunks and branches on the right with the half-rigger and ultramarine and burnt umber.

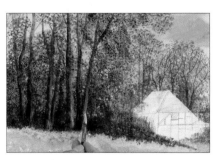

14. Continue painting trunks on the left in the same way, then change to the medium detail brush and paint larger trunks. Allow to dry. Highlight the right-hand sides with white and pale olive green.

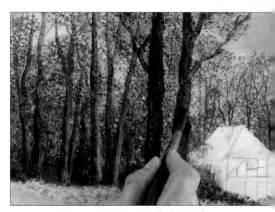

15. Use the large detail brush and burnt umber and olive green to paint the large tree trunks and branches. Allow to dry.

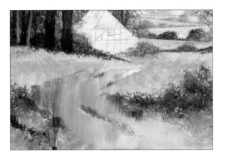
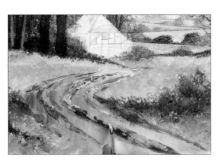

16. Use the wizard with cobalt blue and white to block in the water in the track, making it whiter in the distance. Stroke down reflections of the background trees with burnt sienna and ultramarine.

17. Change to the medium detail brush and paint the water's edge and the ruts in the track with the same mix. Add highlights with yellow ochre and white.

18. Paint reflections of the large trees with burnt umber and olive green, then highlight the lit sides of the trees and their reflections with pale olive green. Add extra branches with the half-rigger and burnt umber and ultramarine.

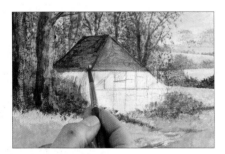
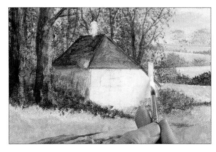
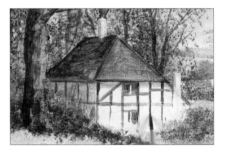

19. Paint the gable end of the roof with burnt sienna, and the shadowed side and under the eaves with burnt sienna and ultramarine.

20. Shade the left-hand side of the house with cobalt blue and burnt umber, then paint the front and the chimney with white and a touch of yellow ochre. Allow to dry.

21. Shade the chimneys and under the eaves with the small detail brush, burnt umber and cobalt blue. Paint the dark timbers and windows with burnt umber and ultramarine.

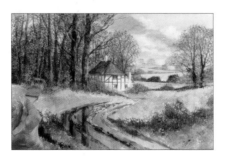
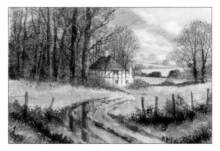

22. Use the golden leaf brush and a mix of white and raw sienna and stipple undergrowth along the base of the wood. Stipple yellow ochre and white over the winter trees to soften them.

23. Mix in pale olive green and stipple this along the base of the woods to vary it.

24. Paint the fence posts with burnt umber and ultramarine on the medium detail brush, then add the wire with the half-rigger.

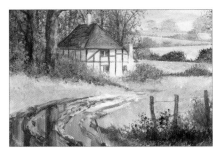 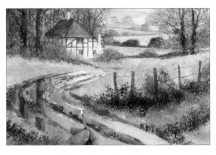

25. Paint the reflection of the house with the small detail brush and white, then burnt sienna for the roof.

26. Highlight the foreground water with the wizard brush and white, then add further touches of white with the small detail brush.

27. Paint reflections of the fence posts with burnt umber and ultramarine.

The finished painting.

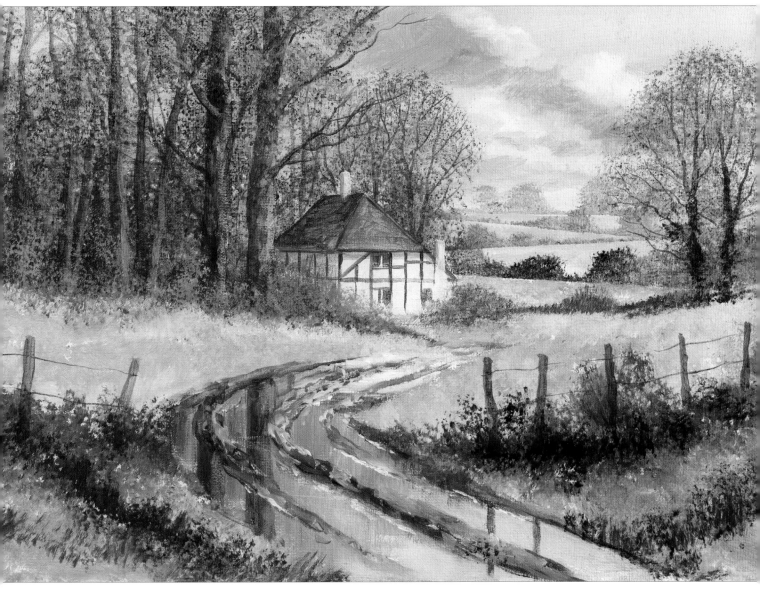

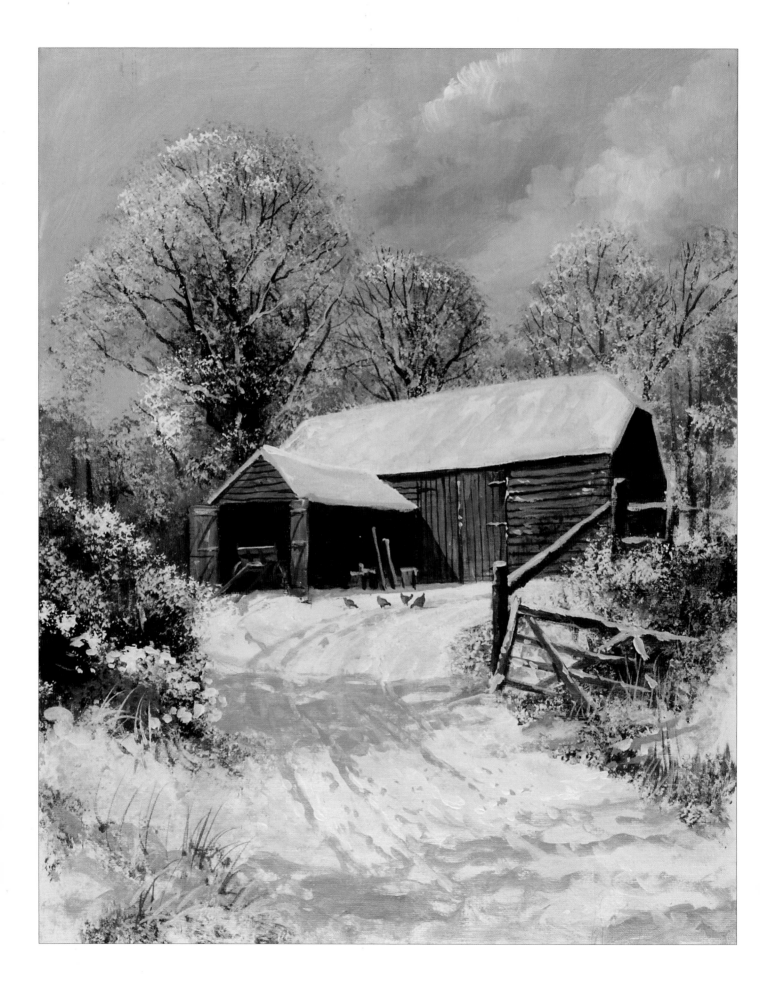

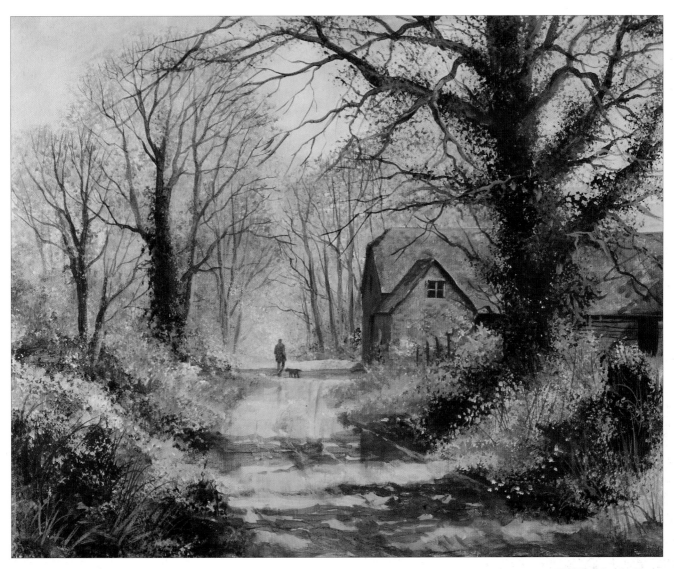

Walking in the Lane

The large tree in the foreground and the shadows across the lane help to frame the farm in the distance. Next to the farm is a man walking his dog, and this becomes the focal point. The golden leaf brush was used to paint the ivy on the trees and the trees in the background. The half-rigger was then used to good effect to paint the tree trunks and branches. Adding life to a painting, for instance figures or animals, can transform a mundane scene into something of interest.

Opposite

Snow Shadows

To make a barn stand out from the background, it is important to have dark trees behind the snow-covered roof. The chickens in the farmyard provide some colour and interest to the centre of the painting. The shadows in the foreground cross the lane to link one side of the painting with the other. This helps to frame the barn and stops the eye drifting out of the bottom of the picture. The final touch is the dusting of snow over the trees, which was stippled using the golden leaf brush.

Coastal View

Texture paste can add another dimension to your painting, in more ways than one. Not only can you see the texture, you can feel it too. This stretch of rugged Cornish coastline is an ideal subject for the addition of texture paste, as well as for experimenting with painting distance and recession.

You will need

Canvas board, 50.8 x 40.6cm (20 x 16in)

2B pencil

Foliage, large detail, golden leaf, 19mm (¾in) flat, medium detail

Paints – see page 10

Texture paste and painting knife

1. Draw the scene with a 2B pencil and use a painting knife to apply texture paste to the rocks and cliffs. Allow to dry.

2. Use the foliage brush to paint the sky with cobalt blue and white, then paint clouds with ultramarine, burnt umber and white.

3. Paint the grass on the distant headland with cobalt blue, white and Hooker's green, then paint the nearer headland with a stronger mix. Add pale olive green to paint the next headland.

4. Add yellow ochre to paint the next headland, then paint the one that is nearer still with Hooker's green and olive green. Mix white and yellow ochre and stipple texture on to the cliff edges.

5. Paint the most distant cliff face with cobalt blue, raw sienna and white on the large detail brush, then paint each cliff face coming forwards with progressively darker mixes of these colours.

6. Paint areas in raw sienna, then paint cobalt blue and raw sienna in the surrounding cliff.

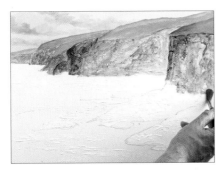

7. Paint the foreground cliff with ultramarine and burnt umber, then add raw sienna.

8. Extend the cliff colours out into the foreground rocks and add crevices with burnt umber and ultramarine.

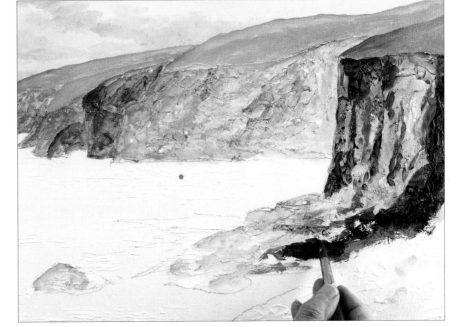

9. Push and drag the same colour over the other cliff faces, catching the textured surface with the brush to create the rocky texture.

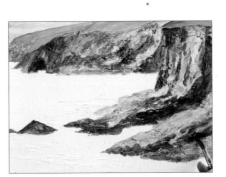

10. Paint the rocks at the bottom of the painting with raw sienna, then burnt umber and ultramarine.

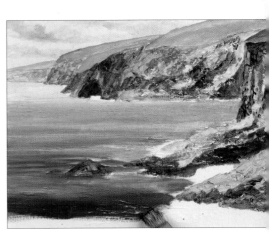

11. Use the golden leaf brush to paint the distant sea with cobalt blue, a touch of Hooker's green and white. Make the mix progressively stronger as you come further forwards. Allow to dry.

12. Use the 19mm (¾in) flat brush to paint ripples with the strong blue-green mix. Allow the ripples to catch the edges of the texture paste.

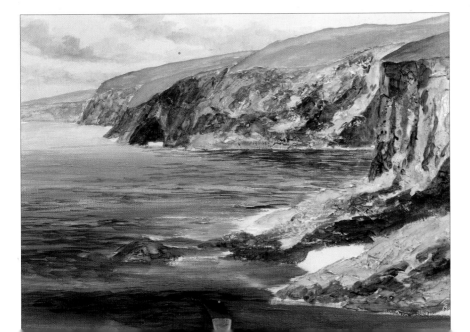

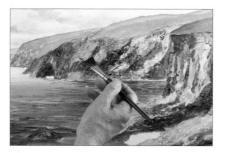

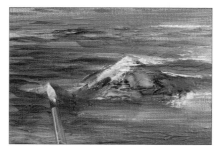

13. Still using the flat brush, drag ultramarine and burnt umber down the slope of the cliffs to catch the texture.

14. Use the medium detail brush and white with yellow ochre to reinstate any rocks that were painted over with the sea colours.

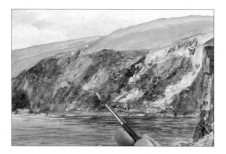

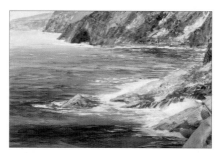

15. Catch the surface of the cliffs with the same mix to add highlights.

16. Use white paint to add ripples, foam and spray to the sea, and water running off the rocks.

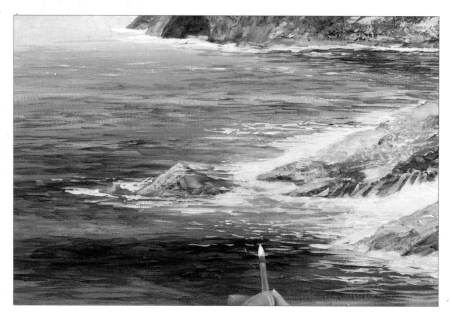

17. Paint more white on some of the texture paste ridges to create ripples.

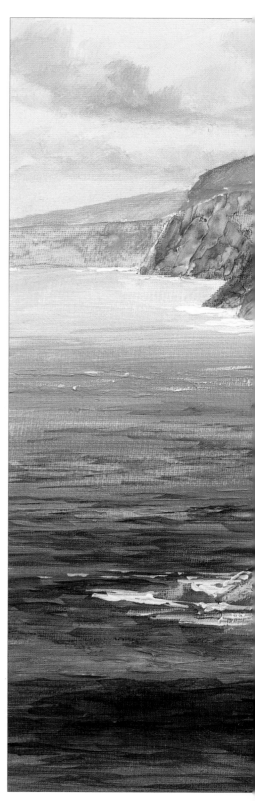

The finished painting.

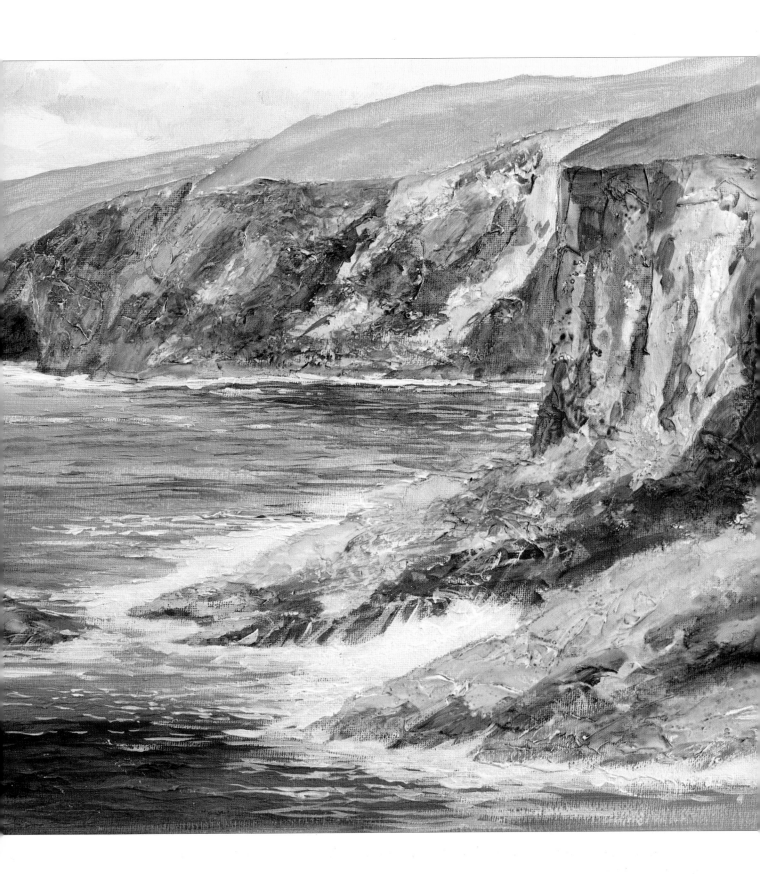

The Fishing Port

Mevagissey is a lively, bustling fishing port on the south coast of Cornwall, with plenty of fabulous subjects to paint. I have chosen a view across the harbour to the colourful cottages rising up above the quay. In the harbour are plenty of small boats with a mass of colourful detail. I have added three rowing boats in the foreground to help fill the open water at the bottom of the painting. I felt that the background was too busy, with no focal point, so bringing in the rowing boats provided some impact to the foreground.

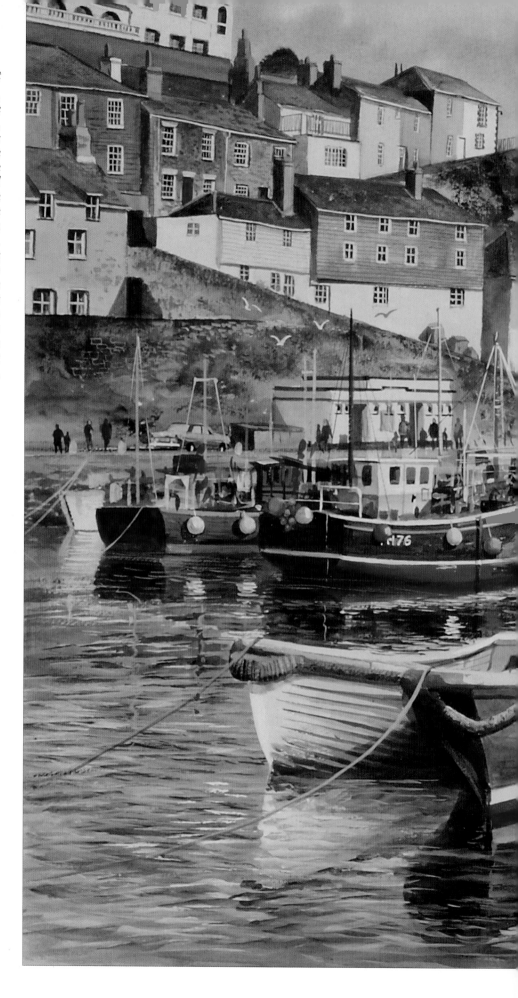

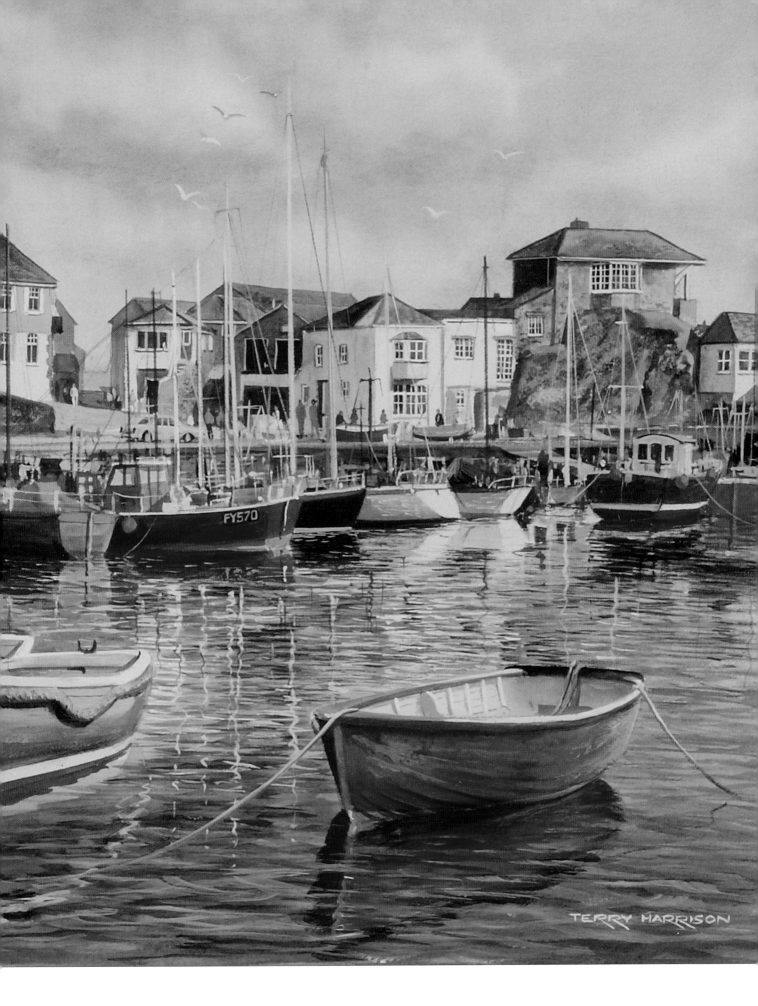

FY570

TERRY HARRISON

105

Landscape with Barn

Barns make fabulous subjects to paint; they represent shelter from the elements and an idyllic, rugged way of life, living off the land in the big outdoors. Barns come in all sorts of shapes and sizes; this one nestles in a valley by a stream with the Blue Ridge Mountains in the distance. The stream leads you into the painting to the barn. The distant hills and mountains are pale blues and greens, in contrast with the strong foreground colours, which adds depth to the painting.

You will need

Canvas board, 50.8 x 40.6cm (20 x 16in)

2B pencil

Golden leaf, foliage, half-rigger, medium detail, large detail, small detail, wizard, 19mm (¾in) flat

Paints – see page 10

1. Draw the scene with a 2B pencil.

2. Use the golden leaf brush to paint the sky area with cobalt blue and white. Paint clouds with white and raw sienna, then shade them with ultramarine and burnt umber.

3. Paint the distant hill with the foliage brush and a mix of ultramarine, alizarin crimson and white. Hold the brush end vertically and stipple trees on a nearer hill.

4. Stipple texture on this area of trees with cobalt blue, pale olive green and white.

5. Texture the area slightly further forwards with raw sienna, cobalt blue and white. Stipple white and pale olive green on top of this.

6. Stipple the hill on the left of the barn with white and raw sienna. While this is wet, stipple cobalt blue and alizarin crimson on top.

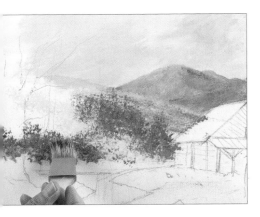

7. Mix white and cadmium yellow and use the golden leaf brush to paint the area of foliage on the left of the barn, then stipple raw sienna and olive green on top. suggesting tree shapes.

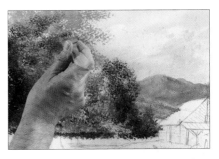

8. Add Hooker's green and stipple over the area with the darker mix. Mix white, cobalt blue and olive green and stipple foliage up to the top of the painting, then stipple a stronger mix on top.

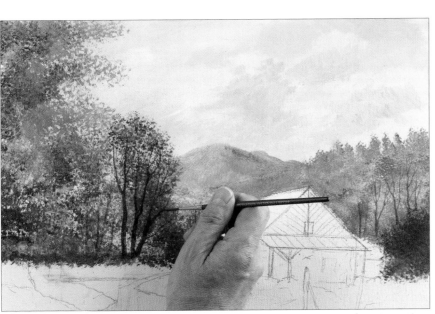

9. Stipple the same foliage mix on the right of the painting, then use the half-rigger to paint distant tree trunks with Hooker's green and burnt umber.

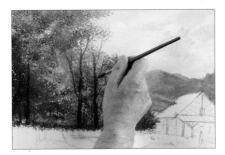

10. Change to the medium detail brush to paint slightly nearer tree trunks and branches.

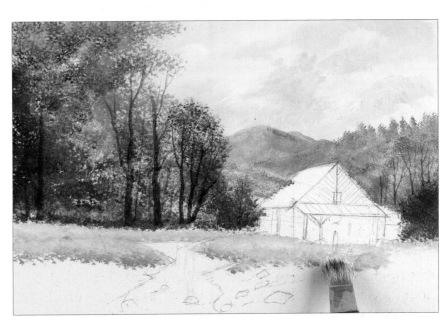

11. Stipple the base of the wooded area with yellow ochre and white, then add raw sienna coming forwards.

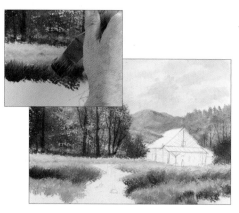

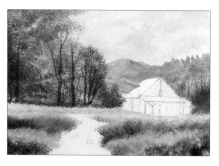

12. Flick up grasses in the foreground on either side of the stream with olive green and raw sienna. Add white to the mix and flick up more grasses to vary the area.

13. Make a dark mix of olive green and Hooker's green, and flick up grasses at the bottom of the painting.

14. Use the large detail brush with a mix of Hooker's green and burnt umber to paint the trunk and branches of the large tree on the left.

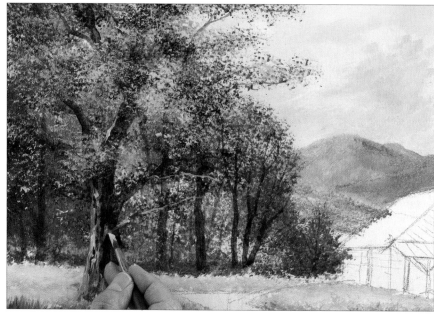

15. Stipple the foliage with the golden leaf brush and a mix of Hooker's and olive green. Allow to dry, then stipple white and pale olive green highlights on top. Do the same to the far right-hand tree.

16. Change to the medium detail brush and add highlights and texture to the sunlit left-hand side of the main tree trunk.

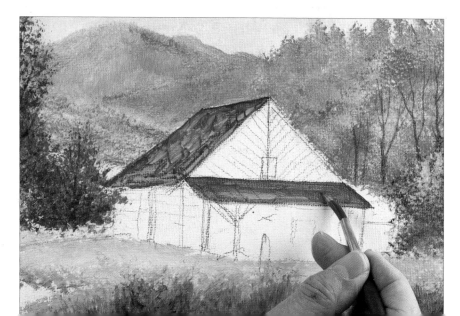

17. Paint the barn and leanto roofs with burnt sienna, and while this is wet, drop in a touch of yellow ochre.

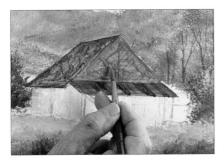

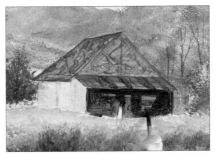

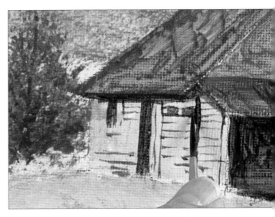

18. Paint darker sections of the lean-to roof with burnt umber, in the direction of the roof's slope. Paint the lit left-hand side of the barn with white, cobalt blue and a touch of raw sienna, then paint the gable end with a darker mix.

19. Block in the right-hand side of the barn with the same mix, then paint the dark interior with ultramarine and burnt umber. Allow to dry, then suggest shapes inside with a darker mix.

20. Use the half-rigger and the same dark mix to paint the shadow under the eaves, windows, a door and horizontal planking.

21. Paint the herringbone planking detail on the gable end and the horizontal planking on the right-hand side, and add another door.

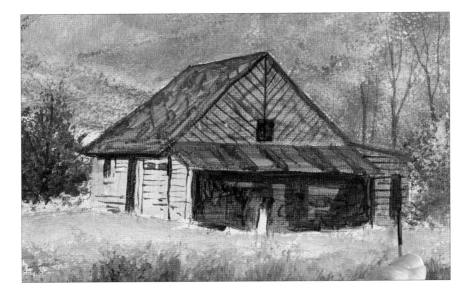

22. Paint a line of the roof colour, burnt sienna, down the right-hand edge of the gable roof.

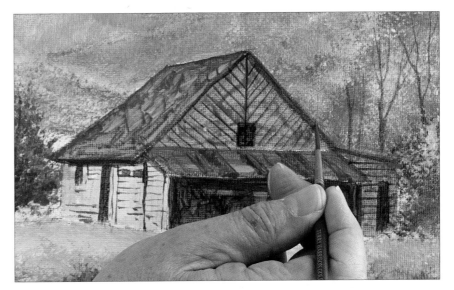

23. Mix white and yellow ochre and use the small detail brush to paint light patches on the tin roof.

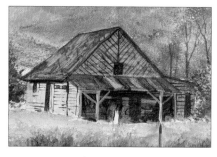

24. Paint the posts of the leanto and the diagonal supports with white, cobalt blue and raw sienna.

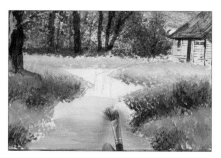

25. Use the wizard and a mix of white and cobalt blue to paint the water with horizontal strokes, making it lighter in the distance.

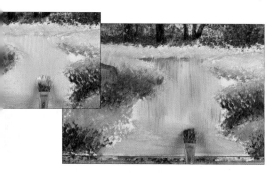

26. Mix cadmium yellow, pale olive green and white to reflect the brightness in the foliage and pull this down into the water. Sweep down a mix of raw sienna and olive green to add darker touches.

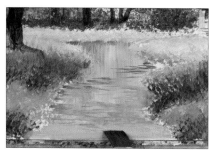

27. Use the 19mm (¾in) flat brush and a mix of cobalt blue and olive green to paint horizontal ripples.

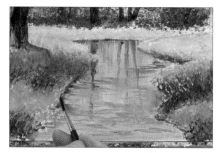

28. Change to the small detail brush and a mix of burnt umber and Hooker's green and paint reflections of the tree trunks, fading them off at the bottom. Paint the same colour at the water's edge.

29. Use the 19mm (¾in) flat brush again to paint light ripples with white and a touch of cobalt blue, then paint white ripples with the small detail brush.

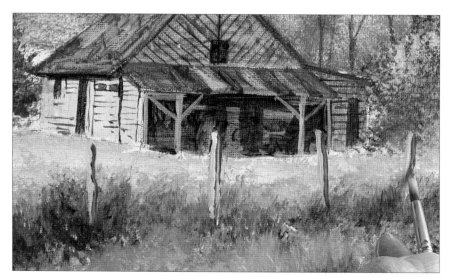

30. Paint the fence posts with cobalt blue, raw sienna and white, then shade the right-hand sides with ultramarine and burnt umber.

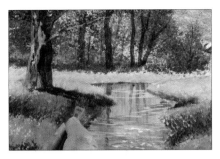 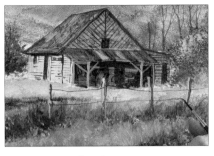

31. Use the wizard to paint shade under the main tree with Hooker's green and olive green, and add some of the same mix on the opposite side of the stream.

32. Paint the fence wires with the half-rigger and burnt umber.

33. Touch in flowers in the foreground with the small detail brush and a mix of cadmium yellow and a touch of white.

The finished painting.

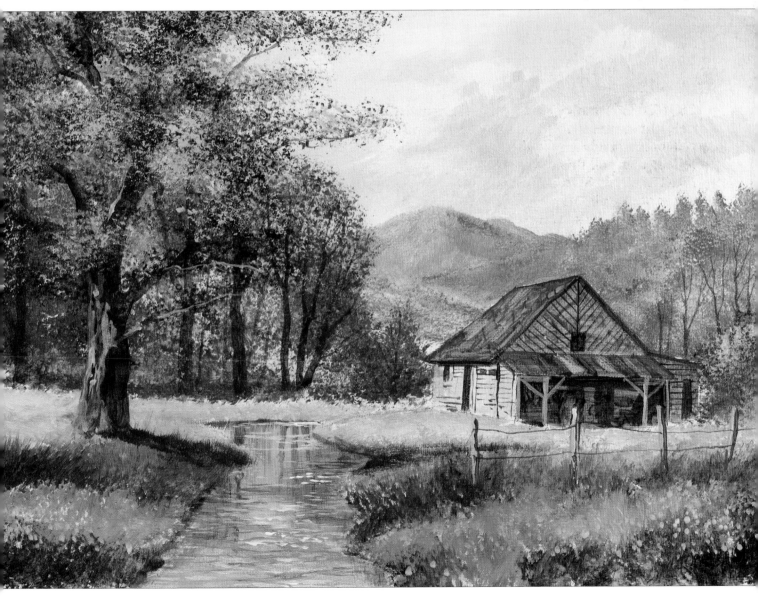

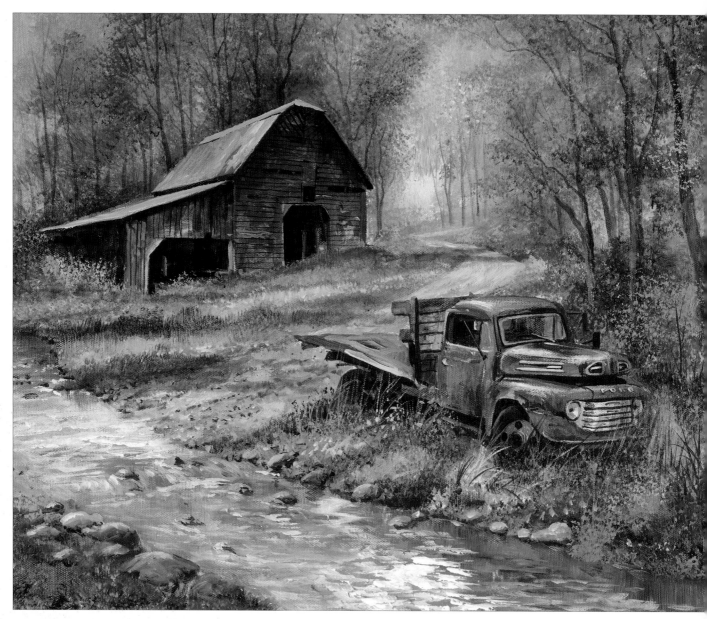

The Old Ford

This variation on a theme of an old barn by a stream is turned round by introducing a different focal point: instead of the barn being the main subject, the old flat-bed truck is now the star of the painting. To add another twist in the tale, this restful setting is by a river, with a ford. So does the title refer to the river crossing, or the old truck?

<div align="right">

Opposite

Hillside Barn

Creating depth in a painting can make the main subject more prominent. In this painting the barn stands out, set against the soft, pale distant trees. The viewer is then led in a zigzag fashion along the fence to the cart, then over the bridge and back into the painting, along the stream to the waterfall.

</div>

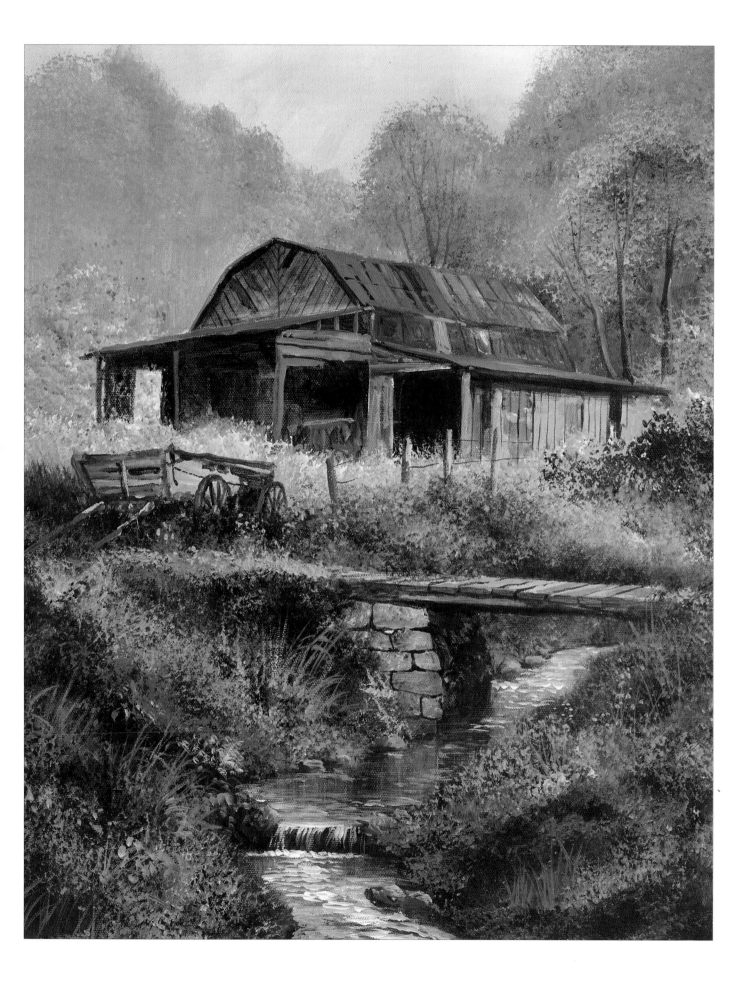

Venice

Choosing a view of Venice is not difficult – everywhere you look there is a painting waiting to be painted. This iconic view near Piazza San Marco of gondolas moored in a row was irresistible. In this demonstration I will show how you can paint over your original drawing then re-draw your image again with the help of some tracing paper and tracedown paper. Tracedown paper is available in black or white. Most of the ripples and the reflections of the gondolas were painted using the 19mm (¾in) flat.

You will need

Canvas board, 50.8 x 40.6cm (20 x 16in)

2B pencil

Golden leaf, medium detail, small detail, foliage, half-rigger, 13mm (½in) flat, 19mm (¾in) flat, large detail

Paints – see page 10

Tracing paper, tracedown paper and ballpoint pen

1. Draw the scene with the 2B pencil. The diluted mixes used for the sky and water should allow the drawing to show through. Use tracing paper to trace the drawing of the boats and reflections so that you can reinstate them later.

2. Paint with horizontal strokes across the middle of the sky with the golden leaf and diluted cadmium yellow, permanent rose and white. Make the wash stronger higher up.

3. Paint a diluted mix of permanent rose, cobalt blue and white at the top and blend in, then paint the top of the water with white, cadmium yellow and permanent rose. Paint over the boats.

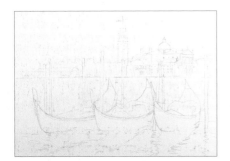

4. Lower down in the water, paint a diluted mix of ultramarine, permanent rose and white, then paint a stronger mix down to the bottom. Allow to dry.

5. Use the medium detail brush to block in the buildings with a mix of white, ultramarine, permanent rose and a touch of burnt sienna. Vary the mix.

6. Paint the tower, dome and roofs with a grey mix of cobalt blue, alizarin crimson and burnt sienna.

7. Add Hooker's green to the grey mix to paint the trees on the island.

8. Suggest detail on the buildings with the small detail brush and a mix of ultramarine and burnt umber.

9. Use the foliage brush with a mix of burnt sienna and white to stipple texture over the buildings.

10. Suggest the clutter of boats at the base of the buildings with the medium detail brush and ultramarine, burnt sienna and permanent rose, then add masts with the half-rigger and white. Add highlights to the white face of the right-hand building.

11. Use the 13mm (½in) flat brush with white and cadmium yellow to paint ripples with little horizontal strokes in the distance. Change to a mix of ultramarine, permanent rose and white coming forwards, slightly overlapping the distant ripples but avoiding the boats.

12. Add more ultramarine and paint larger ripples in the foreground using the 19mm (¾in) flat. Allow to dry.

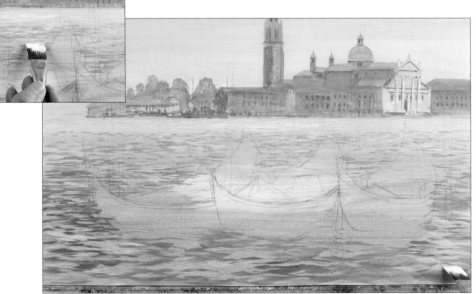

13. Mix cadmium yellow and white to create lighter ripples at the top of the water, bringing them down into the other ripples to create a mix of colours. Use the corner of the brush for the more distant ripples. Then mix white and cobalt blue and create lighter and larger ripples in the foreground.

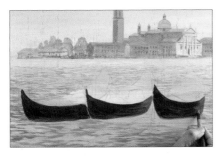

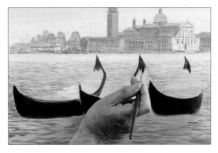

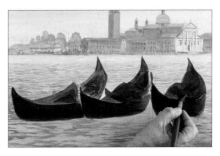

14. Use the large detail brush to block in the gondolas with ultramarine and burnt umber, then add a touch of white to paint reflected light on the right-hand sides of the two right-hand gondolas.

15. Paint a darker mix at the left-hand sides of the gondolas and blend this into the lighter parts. Change to the medium detail brush to paint the pointed ends of the gondolas.

16. Paint the blue covers with the large detail brush and ultramarine, cobalt blue and a touch of white, then add burnt umber to paint folds and texture.

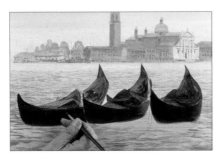

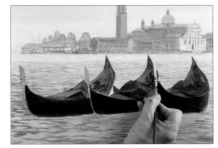

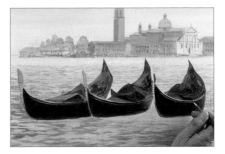

17. Add lighter detail with ultramarine, cobalt blue and white, then darken the edges of the boats with ultramarine and burnt umber. Allow to dry.

18. Mix white, ultramarine and burnt umber to paint the bow decorations, then paint dark details down the left-hand sides with the small detail brush and a darker mix.

19. Mix white with cobalt blue and ultramarine to paint the white lines on the rims, then add pure white highlights.

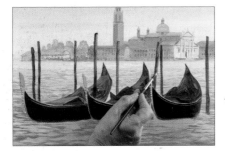

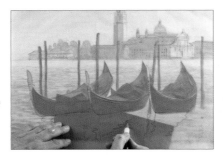

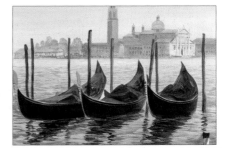

20. Paint the mooring posts with the medium detail brush and burnt umber and ultramarine, then add highlights on the right-hand sides with white and raw sienna. Allow to dry.

21. You will have painted over some of the pencil lines, so tape the tracing over the painting and slip tracedown paper under the image where required. Go over the lines with a ballpoint pen.

22. Use the 19mm (¾in) flat with ultramarine and burnt umber to paint the reflections of the gondolas, and the 13mm (½in) flat to paint the reflections of the poles with a rocking motion.

23. Paint a few light ripples among the dark reflections with white and ultramarine, then use the small detail brush and white to paint sparkling highlights.

24. Use the half-rigger to paint the mooring ropes with ultramarine and burnt umber.

25. Change to the 19mm (¾in) flat brush and darken the reflection just beneath the boats with the same dark mix and horizontal strokes.

The finished painting.

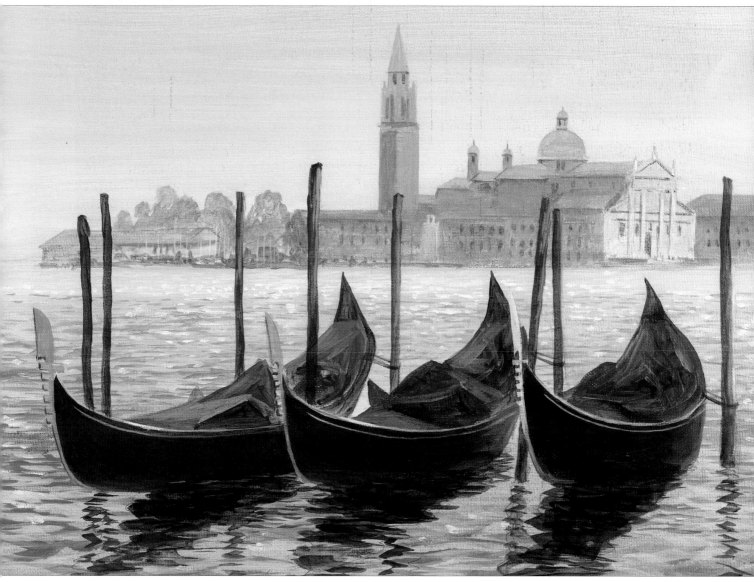

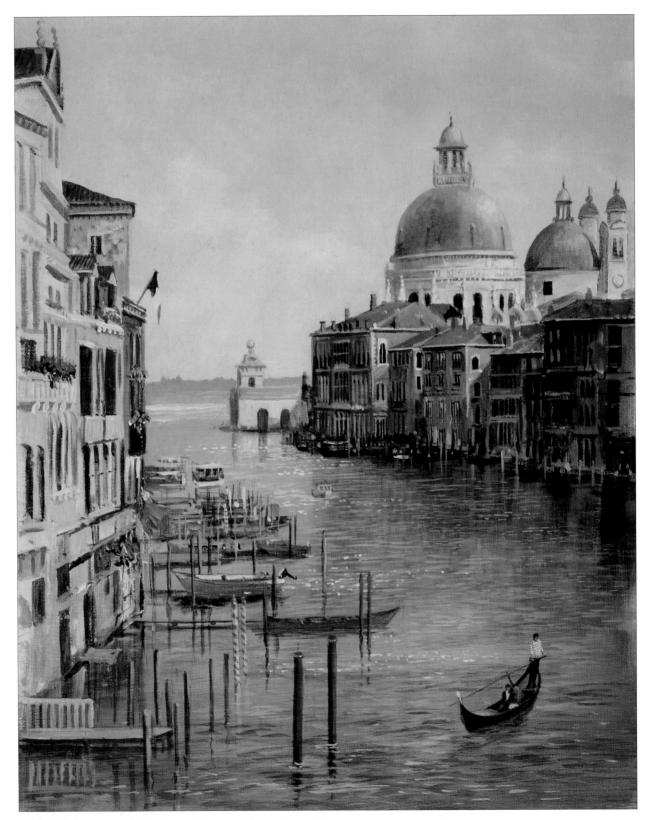

Grand Canal, Venice

This iconic view of Venice is not a simple subject to tackle, but on closer inspection, most of the detail is quite loose. There is plenty of detail, however, and this makes the painting appear busy and full of interest. The water is quite dark in places from the reflections of the buildings. Painted over the top of the reflections are light blue ripples, and in places I have used white straight from the tube to add some sparkle to the water.

Romantic Weekend

Cross any bridge in Venice and you can see why this is one of the most visited and painted cities in the world. As the gondolas silently glide through the water, the reflections of the buildings are churned up, and I have portrayed this using short horizontal brush strokes. I used a 13mm (½in) flat brush to paint the ripples and reflections and finished off using a medium detail brush.

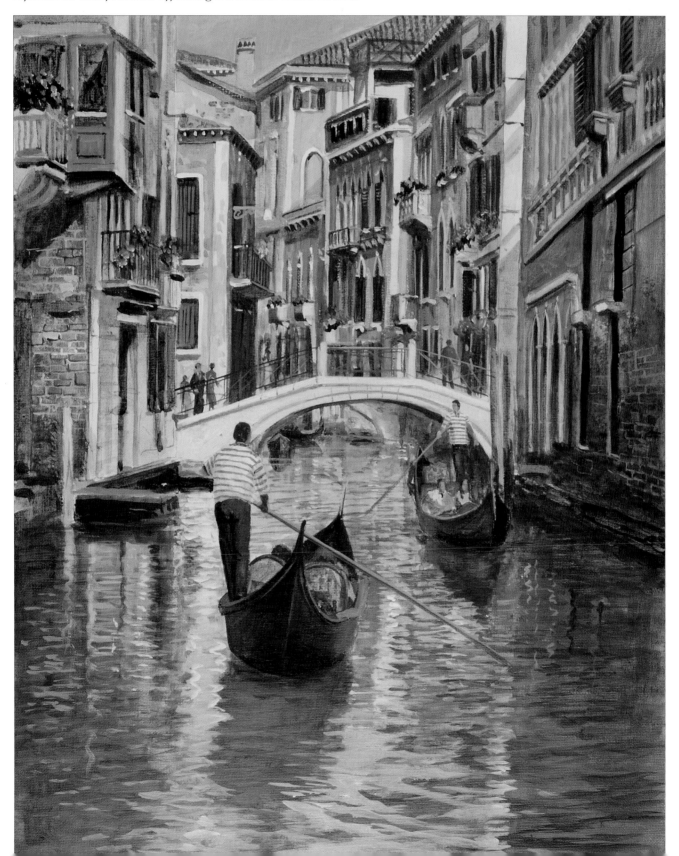

Wisteria

One of the problems of painting with acrylics is that sometimes you need to paint over your original drawing. As in the previous project, in this one I show you how to use tracing paper and tracedown paper to help re-establish your line drawing.

Living in the Cotswolds, I am surrounded by beautiful countryside and quaint little villages. I have chosen this wisteria-clad cottage for this project mostly because I love the colour of the wisteria – it reminds me of bluebells.

You will need

Canvas board, 50.8 x 40.6cm (20 x 16in)

2B pencil

Foliage, medium detail, large detail, small detail, half-rigger, golden leaf

Paints – see page 10

Tracing paper, tracedown paper and ballpoint pen

Paper for mask

1. Draw the scene with a 2B pencil. Use tracing paper to trace elements that will be painted over: the door, the lower window and the tiles above it.

2. Mix white with a touch of raw sienna and paint the wall behind the wisteria with the foliage brush. Add yellow ochre as you go to vary the colour.

3. While this is wet, dab in a mix of cobalt blue and white.

4. Block in the lower wall with a light mix of white, yellow ochre and raw sienna, then paint the shaded side of the bay window and beneath the wisteria with raw sienna and cobalt blue.

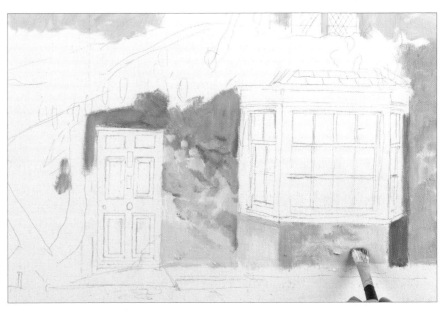

5. Paint more of the wall with yellow ochre, raw sienna and white, then add dappled shadow with the shadow mix of raw sienna and cobalt blue.

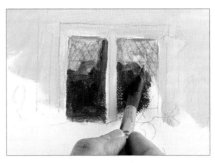

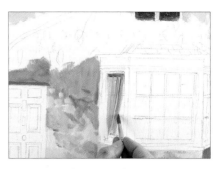

6. Using the same shadow mix, block in the wall behind the wisteria stem. Tidy the lines around the door with the medium detail brush.

7. Use the large detail brush with a light mix of ultramarine and white to paint the top of the dormer windows, and a dark mix of ultramarine and burnt umber lower down.

8. Mix white and raw sienna and use the medium detail brush to paint curtains in the left-hand bay window. Add dark folds with burnt umber and ultramarine.

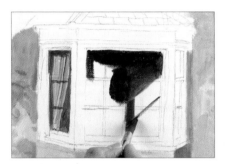

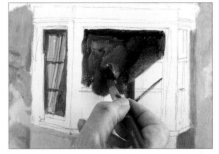

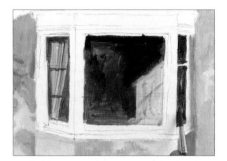

9. Add shade beneath the struts of the window frame, then paint in the dark of the room with the same mix and the large detail brush.

10. Mix white and cobalt blue to suggest reflections.

11. Paint a light shape to the right with white and cobalt blue, then change to the medium detail brush and paint the right-hand window with ultramarine and burnt umber. Allow to dry.

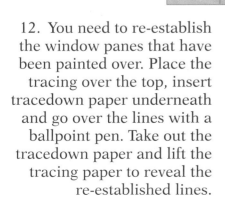

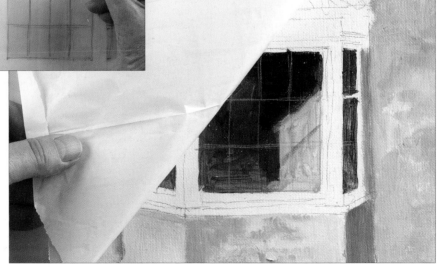

12. You need to re-establish the window panes that have been painted over. Place the tracing over the top, insert tracedown paper underneath and go over the lines with a ballpoint pen. Take out the tracedown paper and lift the tracing paper to reveal the re-established lines.

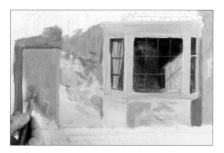

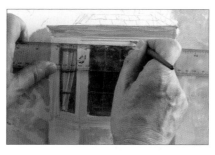

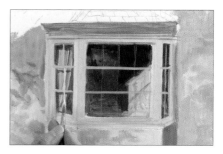

13. Paint the main window frame and the door with white, cobalt blue, raw sienna and olive green.

14. Use the medium detail brush with a darker mix of the same colours to paint the shaded top part of the frame, then use a ruler to help you paint the beading.

15. Paint the horizontal bars of the window frame in the same way, then add the verticals by hand.

16. Paint in the shaded areas of the frame.

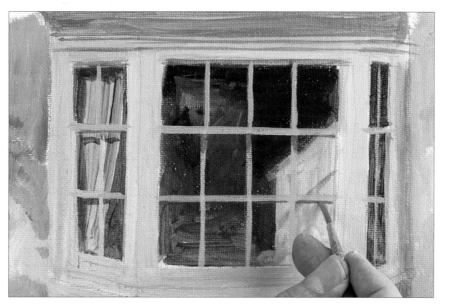

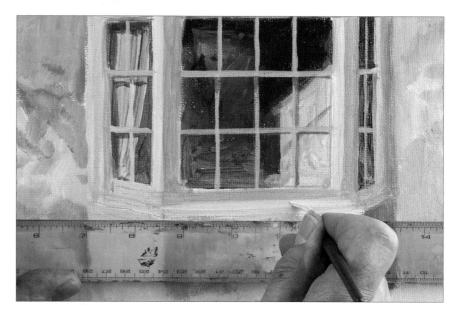

17. Use the small detail brush and white with a little olive green and a ruler to paint a highlight on the windowsill.

18. Paint the shadow under the windowsill with burnt umber and ultramarine.

19. Shade the door panels with olive green, cobalt blue and raw sienna. Shade the top and left-hand sides of the outer panels and the right-hand sides and bottoms of the lower inner panels. Add white to the mix and paint highlights as shown.

20. Add the doorknob, door knocker and letter box with ultramarine and burnt umber.

21. Paint the leading of the dormer window with the half-rigger and the same mix, painting dark over light, then change to white and cobalt blue and paint light over dark lower down.

22. Block in the tile area above the bay window with the large detail brush and ultramarine, burnt umber and white. Shade the top and the underside with ultramarine and burnt umber.

23. Paint the tiles with the small detail brush and the same mix.

24. Mix cobalt blue and raw sienna and use the medium detail brush to paint the recess of the top window.

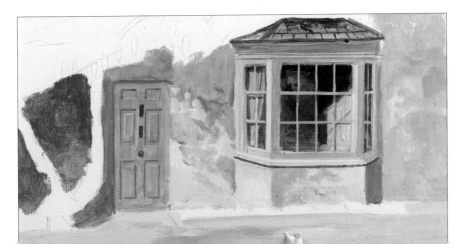

25. Use the foliage brush with white, ultamarine and burnt umber to paint the pavement. Add more ultramarine in places to vary the tone.

26. Mix ultramarine, burnt umber and white to paint the shaded part of the raised flower bed edge.

27. Change to the golden leaf brush and stipple Hooker's green and olive green on to the wall for the wisteria foliage. Add ultramarine and continue stippling.

28. Mix pale olive green, yellow ochre and white and stipple the lighter green over the dark.

29. Stipple a dark mix of Hooker's green and olive green over the bay window roof edge to obscure the line.

30. Use a paper mask to mask the edge of the flower border and stipple the green mixes here.

31. Mix cobalt blue and raw sienna for a shadow mix and stipple dappled shadow over the walls and window frame.

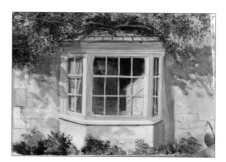

32. Paint the wisteria trunk with the large detail brush and burnt umber and ultramarine, then add lighter areas and create a streaked effect with raw sienna and white.

33. Add branches showing among the foliage with the lighter mix.

34. Use the half-rigger and burnt umber and ultramarine to suggest the edges of stones in the wall.

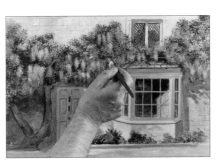

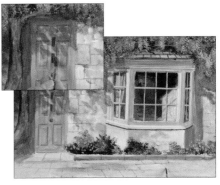

35. Paint pink flowers in the border with the medium detail brush and permanent rose and white. Paint other flowers with cadmium yellow.

36. Mix white, cobalt blue and a touch of permanent rose for the wisteria flowers. Hold the foliage brush vertically to paint the hanging blooms. Add white and highlight the top halves of some of the blooms.

37. Mix cobalt blue, raw sienna and olive green and use the medium detail brush to add dappled shade to the door. Use the small detail brush and cobalt blue with raw sienna to paint the line details in the pavement.

The finished painting.

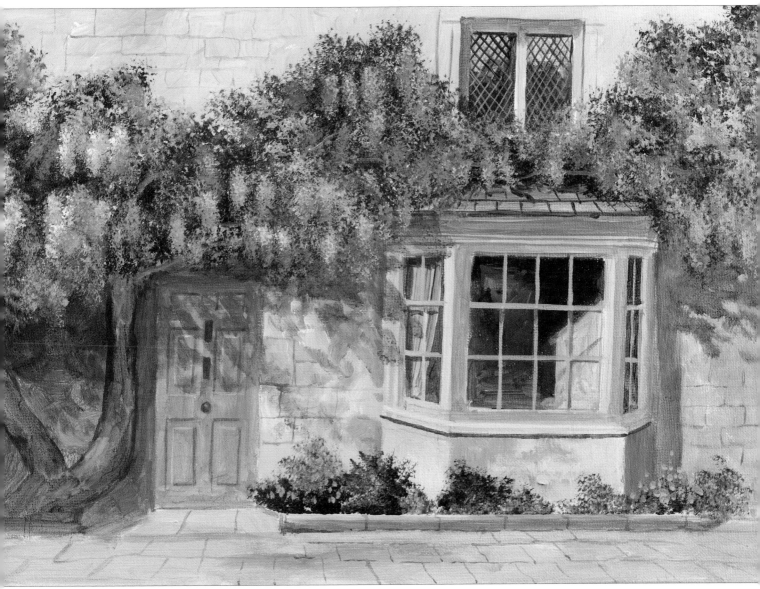

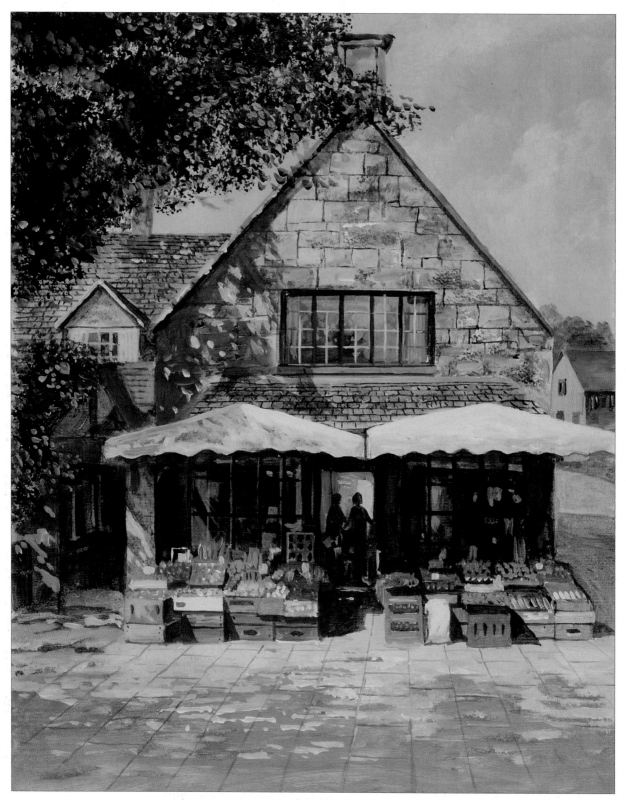

Local Deli

This delightful delicatessen makes a fabulous painting subject, bursting with colours and bustling with detail. The carefully arranged produce spills out on to the pavement, just crying out to be painted. The darks of the overhanging tree and the dappled sunlight in the front create a frame for the sunlit shop front. The half-rigger was used for the detail on the shop wall and the roof tiles. The dark interior is brought to life by the silhouettes of two shoppers.

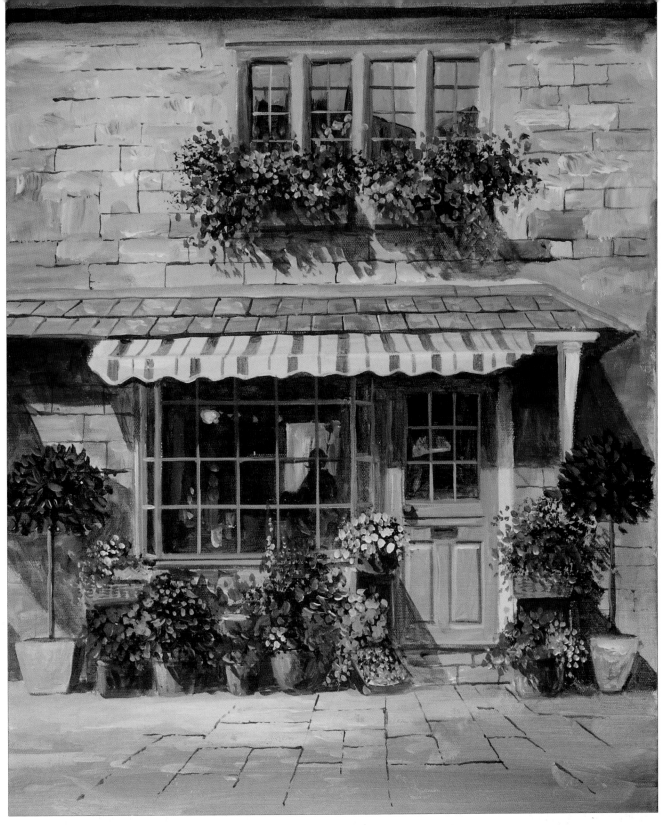

Village Flower Shop

A flower shop brightens up any high street and this one is a real gem – a pleasure to paint with lots of colours and textures. A good tip when tackling a subject such as a shop front is to paint it square on, as this reduces the problems of perspective.

The dark interior of the shop can be brought to life by adding some lights on inside and the silhouette of a shop assistant.

Index

Christmas Classic

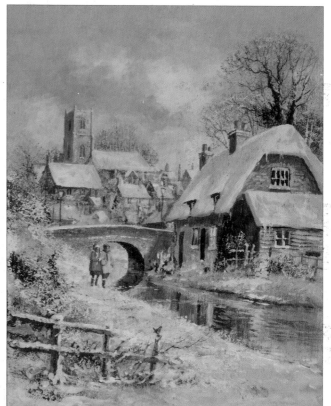